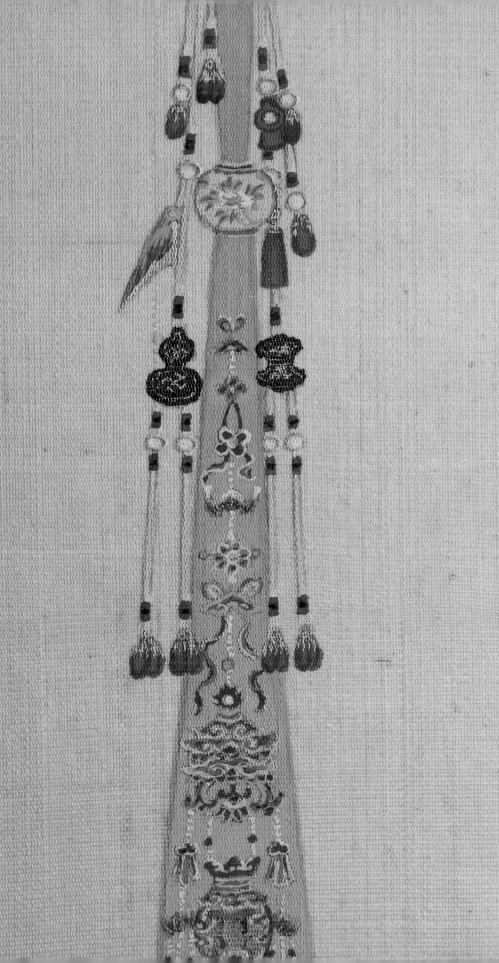

*Dressed to Rule*

18TH CENTURY COURT ATTIRE IN THE
MACTAGGART ART COLLECTION

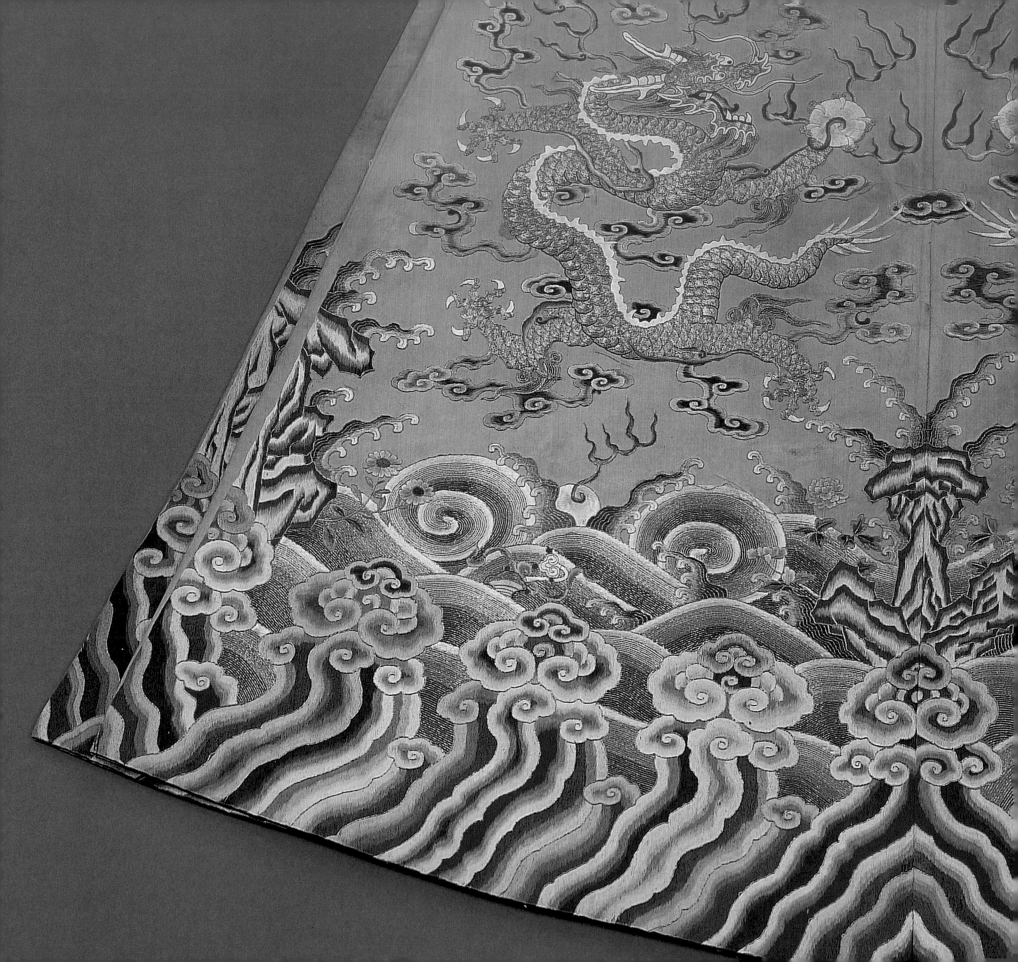

# Dressed to Rule

### 18TH CENTURY COURT ATTIRE IN THE
### MACTAGGART ART COLLECTION

*John E. Vollmer*

museums
UNIVERSITY OF ALBERTA

Gutteridge
BOOKS
An Imprint of The University of Alberta Press

Museums and Collections Services,
University of Alberta Museums
Ring House 1
Edmonton, AB
Canada T6G 2E1

and

University of Alberta Press
Ring House 2
Edmonton, AB
Canada T6G 2E1

*Book Design: Alan Brownoff*
*Text editor: Margaret Barry*
*Photography: K. Jack Clark Photography, Edmonton*
*Scans: Marek Konarzewski, Matt Riddell, and Jim Veldhuis,*
*RR Donnelly, Edmonton*
*Printed in Canada by McCallum Printing Group Inc., Edmonton, Alberta*

LIBRARY AND ARCHIVES CANADA
CATALOGUING IN PUBLICATION

Mactaggart Art Collection
    Dressed to rule : 18th century court attire in the Mactaggart Art
Collection / John E. Vollmer.

Includes bibliographical references.
Guide to the exhibit appearing at the University of Alberta, 2007.
ISBN 978–1–55195–214–7

    1. Costume–China–History–Ming-Qing dynasties, 1368-1912–
Exhibitions. 2. China–Kings and rulers–Clothing–Exhibitions.
3. Mactaggart, Sandy–Art collections–Exhibitions. 4. Mactaggart,
Cécile E., 1939- –Art collections–Exhibitions. 5. University of
Alberta. Museums and Collections Services–Exhibitions.
 I. Vollmer, John E., 1945-
II. Title.

GT1755.C5M32 2007    391'.0220951074712334    C2007–905043–3

Museums and Collections Services and The University of Alberta
Press gratefully acknowledge the support received for its publishing
program from The Canada Council for the Arts. We also gratefully
acknowledge the financial support of the Government of Canada
through the Book Publishing Industry Development Program
(BPIDP) and from the Alberta Foundation for the Arts for our pub-
lishing activities.

Published in conjunction with the exhibition: *Dressed to Rule: 18th
Century Court Attire in the Mactaggart Art Collection* in Gallery A at the
Telus Centre for Professional Development on the University of
Alberta campus, October 20–December 16, 2007.

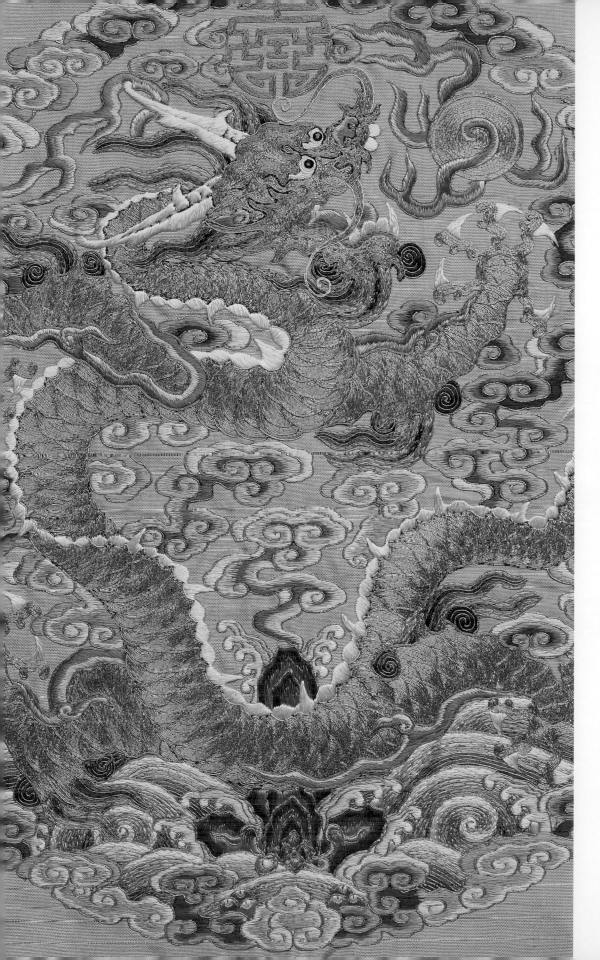

# Contents

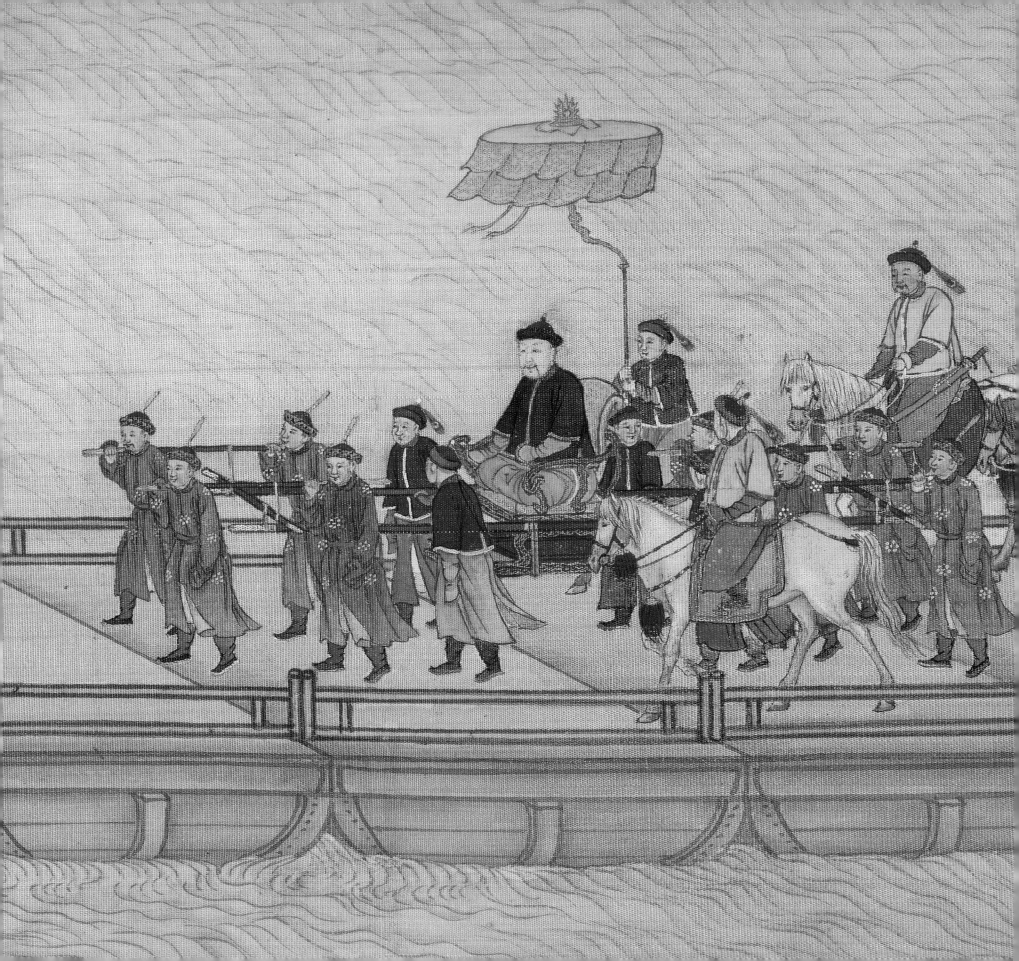

# Acknowledgements

The Qianlong emperor crosses the Grand
Canal near Dezhou carried in a sedan
chair by eight court eunuchs.

*Xu Yang (active c.1750–1776) and assistants, detail
from the second scroll of Nanxantu diqi juan (Pictures
of the Southern Tour); dated to 1770. Hand scroll: ink and
colour on silk; 68.8 cm x 1686.5 cm. University of Alberta
Museums, Mactaggart Art Collection 2004.19.15.1.*
© 2007 University of Alberta

THIS PUBLICATION marks the first exhibition mounted by the University of Alberta Museums in the Telus Centre, the temporary home of the Mactaggart Art Collection. The donation of 734 Chinese paintings, textiles, and costumes by Cécile and Sandy Mactaggart in 2004 and 2005 catapulted the University of Alberta into the ranks of North American museums with important Asian art collections. At the public announcement of the donation, University President Emeritus Roderick D. Fraser declared the Mactaggart donation a "transformative gift that will serve as a catalyst for building world-renown expertise at the University for the study of and research on Chinese culture and history." Indeed, the gift has triggered matching funds from the Province of Alberta's Access of the Future Fund, which allows the University to establish a China Institute for the purposes of forging links between China-related initiatives and scholarship at the University of Alberta. The Institute is committed to enhancing and supporting new teaching and research activities between Canada and China, to developing enduring friendships, and to promoting cultural, scientific, and business exchanges. Other initiatives are underway. The temporary study and exhibition space for the Mactaggart Art Collection at the Telus Centre provides a presence while the University plans a new dedicated museum building that will transform the campus. All of this is in tribute to a couple, who for years maintained such a low profile that few knew of the existence of their collection, let alone their dream of fostering a deeper understanding between China and Canada.

When I first met the Mactaggarts in 1977, I was curator at the Royal Ontario Museum. Their collection was in its infancy; however, even then, it opened possibilities of gaining experience and insights into a much larger field of Chinese textiles. This encounter and others over the following thirty years influenced my research in significant ways. I have had of privilege of organizing an exhibition and writing catalogues illustrated with Mactaggart treasures. I am indebted to Cécile and Sandy for their support of my career, but, more importantly, for their friendship. I am honoured to assist the museum staff with the first public exhibition from this collection that acknowledges the Mactaggarts as collectors and prime movers in this new venture for Alberta.

In 1988, the Mactaggarts acquired a singular set of Chinese court costume illustrations, which significantly transformed their collection, distinguishing it from other public and private holdings. These 34 folios illustrate garments and accessories assigned to the dowager empress, the imperial mother. They were part of an estimated 6,000 folios prepared for the emperor's inspection, which preceded the publication of the black and white woodcut-illustrated edition of the *Huangchao liqi tushi*, or The Illustrated Precedents for the Ritual Paraphernalia of the [Qing] Imperial Court, in 1766. This legislation classified all of the clothing and accessories used by the Qing dynasty court from the emperor to the lowest functionary and are pivotal to our understanding and appreciation of the development of Qing dynasty court dress. The University of Alberta is now the only museum in North America where one can study both the folios and comparable examples of eighteenth-century court dress.

In discussions with Janine Andrews, Executive Director, Museums and Collections Services, and her team about the strengths of the Mactaggart Art Collection, it was immediately evident that these folios and garments from the Qianlong imperial court had to be the focus for the first exhibition. What follows is an attempt to explain the context of some of those folios and their consequences on a selection of Mactaggart Art Collection robes.

At the University of Alberta, responsibility for handling the myriad of details has fallen to many who responded with dispatch and enthusiasm, juggling their other duties and the demands of the 35 museum collections that make up the University of Alberta Museums. Janine Andrews provided leadership and insight to the project and the team. Frannie Blondheim, Associate Director, served as project manager, co-ordinating my visits and requests and guiding the development and implementation of the exhibition plans. Chantelle De Martin assisted with any and all details as they arose. Curator Jim Corrigan and Collections Digitization manager Pauline Rennick provided insight and guidance in working with the collection and its documentation. Gwyneth Macpherson and Sarah Confer, Collections Assistants, worked with me to examine and record the works of art. Conservator Irene Karsten devised exhibition supports and undertook necessary conservation work to allow us to present these garments and textiles in the safest, most aesthetically pleasing manner possible. Bernd Hildebrandt, Danielle Lemieux, and Kevin Zak designed the exhibition and developed graphics used in the gallery. Linda Cameron, Director, The University of Alberta Press, smoothed the way for this publication and joined the University of Alberta Museums in this venture. Alan Brownoff brought sensitivity to this catalogue's design and greatly enhanced the story of Qing dynasty court dress.

This project has also been greatly enhanced by the expertise and advice of colleagues who over the years have been particularly involved with the Mactaggart Art Collection. The incredible knowledge that painting specialists Arnold Chang and Dr. Maxwell K. Hearne have shared has been insightful and informative, and has frequently led to new discoveries. I have always enjoyed conversations with Carol Conover and Jacqueline Simcox about Chinese textiles, how they are made and what they tell us. Both of these experts brought many of the costumes and textiles to the attention of the Mactaggarts. Their historical knowledge of the field is extraordinary and invaluable, especially when attempting to imagine the past.

I am indebted to artist Richard Sheppard for permitting me to use some of the illustrations he created for *Ruling from the Dragon Throne*, which was published by Phil Wood of Ten Speed Press in 2002.

To my wife Eleanor, my deep affection and most humble thanks for her encouragement and support of my work. Without her it would be impossible to take the time these projects require. Her willingness to read anything I write with a critical eye and ear to what it says and how it is expressed makes me work harder and better.

Transforming ideas and discussions into an exhibition and a catalogue are the result of the efforts of many and I am much indebted to all who contributed to this venture. Any errors in facts or oversights are solely my responsibility.

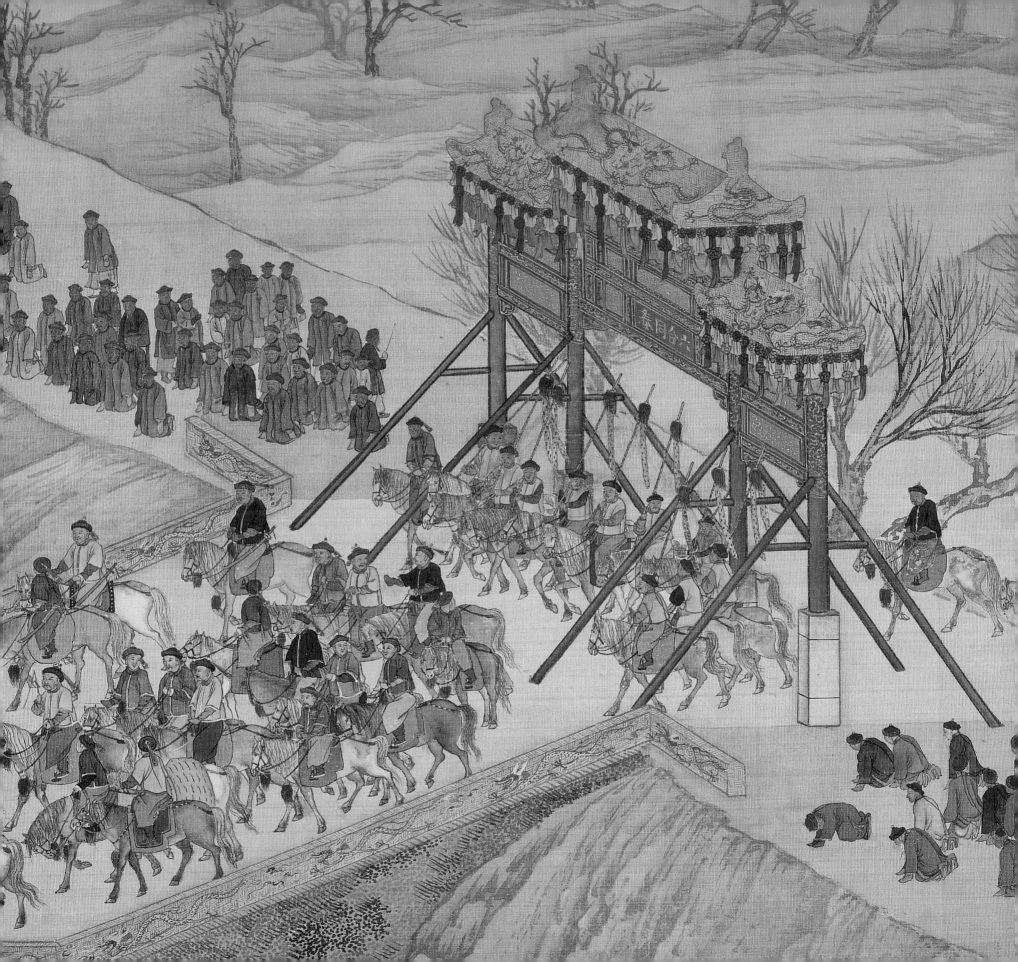

# Foreword

The imperial body guard, distinguished by their short bright yellow surcoats, precede the emperor's arrival into Dezhou. They ride under a temporary ceremonial gate festooned with silk bunting and rosettes. The tiles on the roof and low walls bordering the ramp are made of special glazed ceramic tiles.

*Xu Yang (active c.1750–1776) and assistants, detail from the second scroll of Nanxantu diqi juan (Pictures of the Southern Tour); dated to 1770. Hand scroll: ink and colour on silk; 68.8 cm x 1686.5 cm. University of Alberta Museums, Mactaggart Art Collection 2004.19.15.1.*
© 2007 University of Alberta

IN JUNE 1634, Samuel de Champlain, Governor of New France, sent Jean Nicolet on an expedition to make contact with indigenous tribes beyond Lake Huron and to negotiate profitable fur trade agreements. Nicolet, with his sketchy understanding of unexplored geography, assumed the Winnebago, whom he was attempting to impress, would be acquainted with the majesty of the Chinese court and for the occasion he "wore a grand robe of China damask, all strewn with flowers and birds in many colours." How he came by a "China damask robe" remains a mystery.

Great collectors, like great explorers, display courage and vision. The clarity of Sandy and Cécile Mactaggart's vision can be seen in the focussed nature of their collection of Chinese artworks. They also had the foresight to establish an endowment to prepare and move the collection along with their vision. Consequently, the University of Alberta stands on the brink of a very different encounter with China and, thanks to the donation of the Mactaggart Art Collection, it too is prepared with "grand robes."

*Dressed to Rule: 18th Century Court Attire in the Mactaggart Art Collection* marks a new era of redis-

covery for the University of Alberta Museums. As the oldest public collection in Alberta and one of Canada's largest with 20 million objects and specimens, the University of Alberta Museums are well placed to negotiate the future. Sandy and Cécile Mactaggart's gift, coupled with President Indira Samaresekera's bold and visionary Dare to Discover campaign, has led the University to endorse the development of an innovative world class Curatorial Research Facility where we can engage with and exhibit important international collections like the Mactaggart Art Collection in appropriate ways.

Our inaugural exhibition, *Dressed to Rule*, by our friend and colleague John Vollmer—one of the world's leading experts in Asian textiles—marks the beginning to our public journey with the Mactaggart Art Collection. We are grateful to John for accepting the challenge to work with a new space, a new collection, and a small but enthusiastic staff. His short tenure with us has resulted in a fine exhibition and a noteworthy catalogue for public and student consumption.

*Janine Andrews*

*Executive Director, Museums and Collections Services*

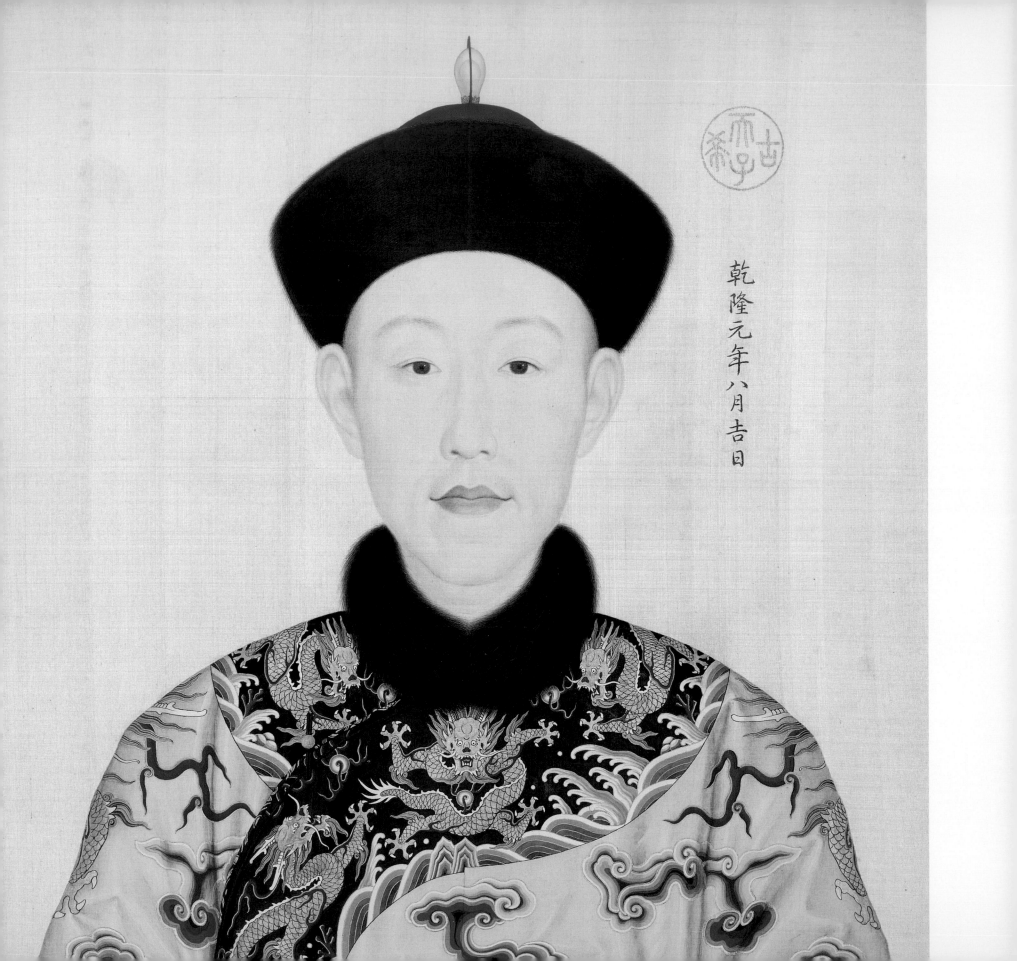

乾隆元年八月吉日

# Introduction

*"All the world's a stage,*
*And all the men and women merely players:*
*They have their exits and their entrances;*
*And one man in his time plays many parts,"*[1]

WILLIAM SHAKESPEARE'S (1564–1616) oft-quoted speech from the second act of *As You Like It* finds a particular resonance in a discussion about Manchu identity. Manchu image, and the role it was to play on the stage of international power politics in East Asia during the seventeenth and eighteenth centuries, was radically transformed at roughly the same time Shakespeare's comedy was first produced in 1599. Other than coincidence and a universal observation about the human condition, there is no link between Shakespeare's Lord Jaques's somewhat melancholy lament about ageing and Nurhaci (1559–1626), the Manchu khan's, dream of imperial power. Nonetheless, Shakespeare's lines aptly summarize the shifting Manchu perceptions of themselves as distinctive ethnic nationals, alien military conquerors of the Han-Chinese people or Heaven-mandated rulers of the most powerful empire in the world.

## Clothes and Identity

ALL OF OUR SOCIAL INTERACTIONS involve identity: who we are; who we want to be; who we are forced to be; how we express it; and what it means. For the most part, identity involves comparison—we are either different from, or, the same as others. But it is seldom a simple choice. Depending upon power structures, we conform or adapt, often negotiating identities between and among polarities. Dress helps us signal identity. Kinship and rank, political function, and social occasion are frequently denoted by a particular dress deemed acceptable by a peer group. Deviations from the norm imply a change of identity. Historically, dress embodied the continuity of a people's lifestyle—its social mores, cultural values, and technological developments. Change in clothing was often bound up with political, psychological, and philosophical considerations, and was seldom achieved without external influence. For the sixteenth-century Manchu people, clothing helped redefine them as a society and as a distinct culture.

As outsiders, the Manchu were keenly aware of the challenges facing non-Chinese rulers and the fate of assimilation that eventually defeated all

previous conquerors from the north. Issues of ethnic separation and cultural accommodation were central to Manchu government policy. From the outset, language and dress played key roles in attempts to impose Manchu will on a much larger Chinese population. By legislating that all who were in service of the Qing government shave their foreheads and wear the back hair in a single braid, or queue, and wear Manchu-style garments, the Qing leadership in effect made everyone Manchu.[2]

## Manchu Dress Makeovers

WITHIN THE SPAN of two generations, the stage on which Manchu society expected to perform expanded radically. The shift from a group of tribal clans living on the margins of the Chinese empire to a multinational martial society that was capable of assuming control of that empire was swift and deliberate. During the late-sixteenth and early-seventeenth centuries, Nurhaci gathered loosely-affiliated Jurchen tribes into a rigorously-disciplined military organization. The institution for this transformation was known as the Eight Banners, (*gusa* in Manchu; *baqi* in Chinese) Eight Banners was named after the distinguishing solid and bordered yellow, white, red, and blue flags that identified the major divisions of the army.[3] Enrolment of an individual warrior into the banner system extended to his family and servants. The banner system provided effective military discipline and comprehensive registration of civilians, which helped guarantee the equitable distribution of lands and taxes that ensured the livelihood of its members.

During the first decade of the seventeenth century, the ranks of new recruits were increased by the Chinese, who switched loyalties, and by alliances with various Mongol tribesmen and some Koreans. Standardization of bannermen's dress became a

priority, whether they were Manchu, Chinese, Mongol, or Korean.

While a consistent dress style had a levelling effect on diverse populations, other political and social pressures influenced the need for a more nuanced and sophisticated wardrobe. The head of each banner was appointed from within the ranks of the Manchu imperial clan. These leaders also sat in council to advice the ruler. As the size and complexity of the Manchu state grew, a civil administrative structure developed with deliberative bodies that facilitated internal and external administration, which were patterned on Chinese models. Signalling rank among the civil administrators and reserving specific garments, colours, and patterns to bolster the prestige of imperial clan was the focus of early dress legislation.

## Dressing to Rule the Universe

THE RAPID GROWTH of the Manchu state during the early seventeenth century resulted in a patchwork of expedient decisions that built identity and solidarity and acknowledged its imperial ambitions. After the conquest of 1644, edicts affecting dress continued to be issued by the throne to curtail abuses and unauthorized use of restricted garments and patterns.

In 1748, the Qianlong emperor (r. 1736–1795), the fourth of the Qing emperors, initiated a comprehensive review of Qing court dress regulation. A decade later the *Huangchao liqi tushi*, or The Illustrated Precedents for the Ritual Paraphernalia of the [Qing] Imperial Court,[4] was issued as an imperial edict in 1759 and was openly proclaimed in 1766. This document classified all clothing and accessories; it also identified all ritual objects and implements used at court. Conceptually, the Qing wardrobe did not change again. These regulations served as the

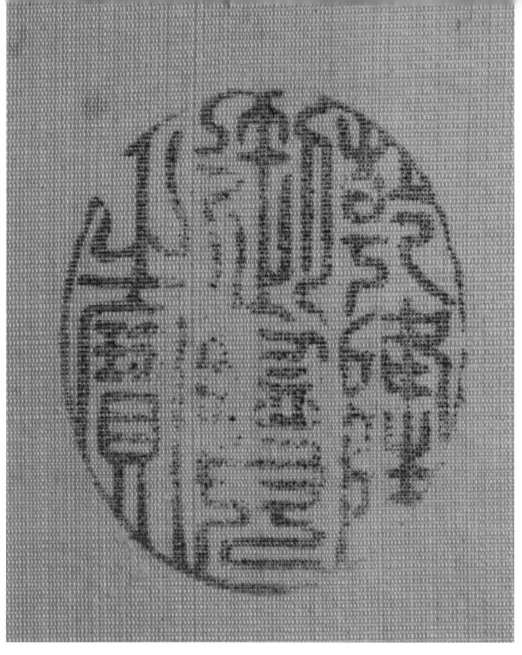

standard for court attire until the dynasty's collapse in 1911. On one hand, the edicts affirmed the determination of the Manchu conquerors to resist increasing pressures to restore native Chinese dress; on the other hand, they effectively transformed the image of the Manchu sovereign from barbarian chieftain to the emperor of a Confucian Chinese state.

This selection of Qing dynasty imperial robes and accessories from the Mactaggart Art Collection, dating from the eighteenth and early-nineteenth centuries, is most closely connected in time to the Qianlong emperor's dress reforms. In them we can discern and deconstruct the workings of the Manchu state in its efforts to strike a balance between issues of national identity and the imperatives of a universal image of Chinese imperial authority. The flexibility, expediency and diligence that we observe in the Manchu search for identity, and the willingness to adjust that image, resulted in a remarkably stable and powerful dynasty, which held sway over the most expansive and diverse empire ever achieved in Chinese history.

The emperor's seal was used to indicate approval of items submitted for his inspection. The *Qianlong zhengshang* (Qianlong has appreciated) seal was stamped on one the album leaves illustrating the wardrobe of the Empress Dowager.

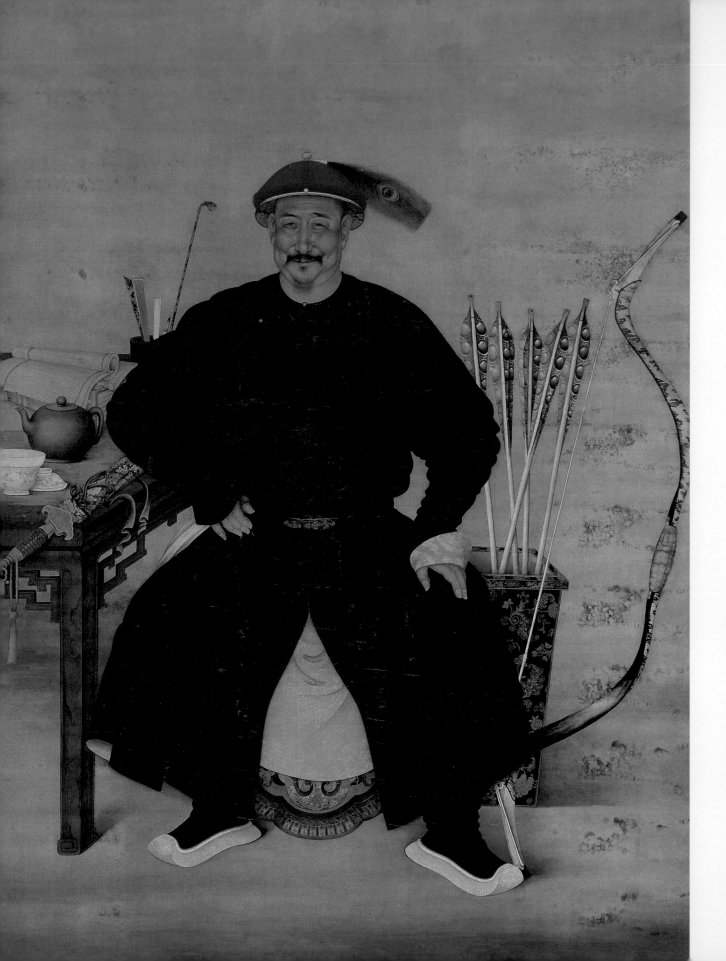

Boots and layers of close-fitting garments characterized the national dress of the Manchu conquerors who established the Qing dynasty. This unknown Manchu officer reveals both his nomadic military prowess and his refined tastes as a Confucian *wenren*, or man of culture.

# Creating Manchu Identity

BEYOND THE EASTERN EXTREMITY of the Great Wall, where it touches the sea at Shanhaiguan, the Eurasian steppe grasslands give way to the forests and marshes of the Amur River drainage. The area lying just outside the wall was the northernmost extension of the territory that sustains Chinese-style agriculture. Here an agrarian economy could support an urban lifestyle, albeit on a reduced scale, and a bureaucratic government based on Chinese models, which often managed administrative affairs. In addition to small numbers of Chinese settlers, the region was inhabited by Tungusic-speaking tribes whose livelihood combined pastoral and sedentary pursuits. Among these tribes were the Manchu.[5]

## Jurchen Heritage

ALL TUNGUSIC-SPEAKING GROUPS traced their origins to the North Asian nomads who lived along the Amur River drainage. The southward migration of some of these groups, which had begun as early as the Han dynasty (206 BCE–220 CE), brought them into contact with horse-riding herder cultures of Inner Asia. Those living on Liaodong Peninsula modified a steppe nomadic lifestyle. By the end of the tenth century, one of these Tungusic-speaking groups had created the confederation known as the Jurchens, a word of uncertain origins. The Jurchens declared the Jin dynasty (1115–1234) and established control of northeast Asia, including all Chinese land north of the Huai River.[6] In the twelfth century, the Jurchen drove the Chinese emperor out of northern China, which precipitated the collapse of the Northern Song dynasty (960–1127). A little over a century later, the Mongol conquest of East Asia established the Yuan dynasty (1279–1368) and swept the Jin, as well as the Southern Song dynasty (1127–1279), from power.

After the fall of the Jin, many Jurchens remained in China, quietly melding into the general population; others withdrew north, settling just beyond the Great Wall, and also became completely sinicized. Some returned to their homeland, settling along the lower reaches of the Sungari River, where they joined other Tungusic-speaking tribal peoples from further north and reverted to a tribal way of life that combined hunting and fishing with limited herding, nomadism, and agriculture.

In the fifteenth century, the Ming dynasty (1368–1644) government identified three Jurchen groups:

Jianzhou (after their prefectural home), Haixi (literally "east of the sea") and Yeren (uncivilized people).[7] The Ming court maintained diplomatic relations with the Jianzhou Jurchens in efforts to play off one clan leader against another, thus keeping the entire group disorganized. In exchange for paying an annual tribute of sable pelts to the Chinese emperor, the Jianzhou Jurchens were awarded trade relations with China. The Ming garrisons established horse markets in several towns, where horses, furs, honey, and ginseng root could be exchanged for tea, textiles, rice, salt, and iron tools.[8] Among the clan groups of the Jianzhou Jurchens were the precursors of the Manchu.

## Manchu Nationality

THESE PRE-MANCHU TRIBES remained politically fragmented until the last decades of the sixteenth century, when Nurhaci, the charismatic chieftain of the Aisin Gioro clan transformed the loosely-aligned clans into a centralized military society. He organized troops into companies of 300 warriors called *niru*, literally "arrow"; five companies formed a *jalan*, or regiment. The regiments were in turn grouped into four large units called *gusa*, or "banners."[9] These were distinguished by yellow, white, red, and blue flags. By 1615, the Manchu ranks had swollen with new recruits, Chinese who had changed allegiance, and Mongol tribesmen—to the point that the four banners were split, creating eight divisions distinguished by the original solid coloured banners and by a new set based on those colours with the addition of contrasting borders. In 1616, Nurhaci claimed the title "bright khan" (*genggiyen han*) over all Manchu and declared the dynastic name Ho Jin, or later Jin, referring to the Jin dynasty, thus claiming legitimacy for Nurhaci's imperial dreams and bolstering the royal pedigree of the Aisin Gioro clan.

Nurhaci's son Hongtaiji (1592–1643), better known by his personal name, Abahai, succeeded to power in 1626. He brought the remaining Chinese parts of Manchuria under his control, even leading plundering forays deep into Chinese territory south of the Great Wall. He transformed the Manchu government by appropriating Chinese civil officials to the Manchu ranks. Hongtaiji extended Manchu control westward and incorporated Mongol tribes into the banner system.

In addition to the banner system's military and political organization, it also functioned as an ethnic preserve. In the 1630s, Abahai created parallel Eight Banner organizations. In addition to the original Manchu banners, he created one to accommodate Mongol tribesmen and another for Chinese soldiers and farmers who joined the Manchu enterprise.[10] This action coincided with the invention of the names Manchu (*Manju* in Manchu, *Manzu* in Chinese) and Manchuria (*Manji gurum* in Manchu, literally, "Manchu nation"). It was part of a strategy that acknowledged the ethnic separation of the Manchu and it ensured their superior status. Manchu outranked their Mongol counterparts; both of these northern groups outranked Chinese bannersmen.

In 1635, the Chinese-style dynastic title *Qing* (pure) was proclaimed. With this action, Hongtaiji declared his opposition to the Ming imperial government, and signalled Manchu determination to claim the Dragon Throne of imperial China. Abahai died in 1643. A year later, internal disorder and decay brought about the collapse of the Ming dynasty, giving the Manchu regent, Dorgon (1612–1650), the chance to place the eight-year-old son of Abahai on the Dragon Throne as the Shunzhi emperor (r. 1644–1661).

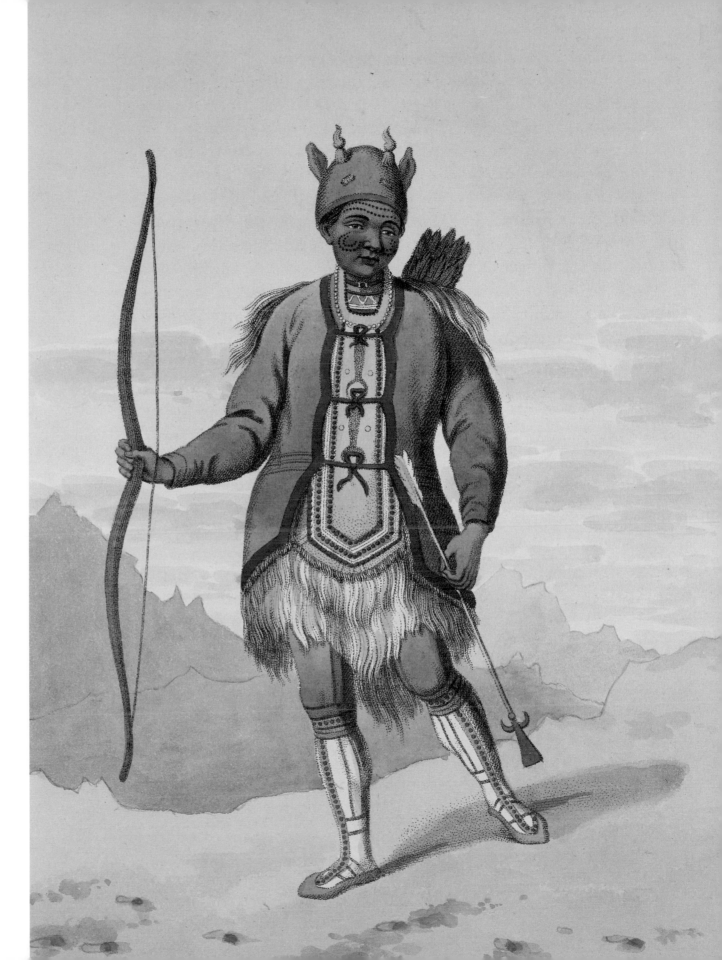

Prototypes of Manchu dress are found in the animal hide dress of Tungusic tribes living along the Amur River drainage. Hats and hoods using deer hides with ears intact were believed to have talismanic properties ensuring a successful hunt.

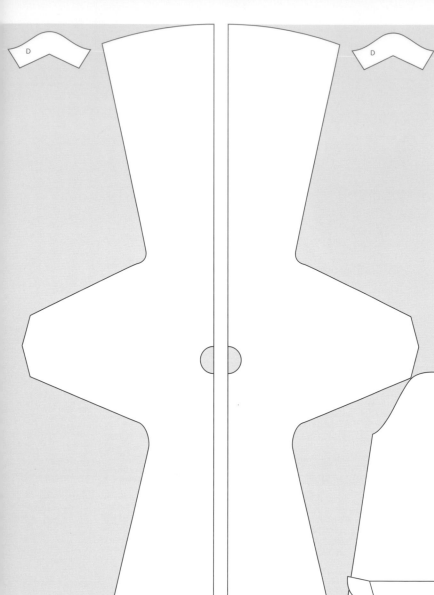

## Manchu Dress

AGAINST THESE POLITICAL DEVELOPMENTS, Manchu dress evolved from simple utilitarian garments, which had initially been made for protection and warmth required for herding and hunting, into sophisticated statements about ethnic identity and universal domination. While there is no record of what pre-sixteenth century Manchu tribes wore, analysis of surviving historical garments and the evidence provided by ethnographic garments collected from North Asian nomads at the end of the nineteenth and early-twentieth centuries permit us to reconstruct the animal hide prototypes for Manchu garments.[11] Coats, made of bulky hides with the fur left on, were knee-length with long, relatively tight-fitting sleeves. They were fastened with pairs of ties or loops and toggles to conserve body heat in winter and to militate against the depredations of mosquitoes and black flies in the summer. Dress also included hide hoods and bonnets, moccasins made in one piece with leggings, and trousers tucked into soft-soled boots.

The horse-riding cultures of Inner Asia contributed other elements of Manchu dress. Horsemen's

Reindeer hide superimposed on a Manchu garment cutting diagram. In order to preserve the profile of the prototype garment, excess fabric was cut away. This uneconomical use of woven material contrasts sharply with garments that textile-producing cultures make.

*Drawing by Richard Sheppard*

coats were mid-calf length or shorter, with asymmetrical front overlaps and very long, tapered sleeves. These belted coats were fitted with rings from which accessories were suspended and which hung at the sides when worn. Such accessories included pairs of drawstring purses and cases for a knife, chopsticks, and a flint. Coats were vented at the centre front and back to keep them from bunching when sitting astride a horse. Leggings or trousers tucked into rigid-soled boots were also part of the horseman's kit, as were hats and hoods that kept the head warm.

Like the garments worn by Turkic and Mongolian tribesmen,[12] Manchu horse-riding garments were made of cloth obtained through trade. These cloth coats were often quilted or faced with fur for added warmth. The Manchu also adopted a variety of auxiliary nomadic garments. Surcoats worn over other garments, which they called *magua*, literally "horse jackets," ranged from waist- to knee-length and had elbow-length sleeves. They added an additional layer of insulation, but more often they transformed the appearance of functional attire, particularly when they were made of contrasting colours or materials. After 1630, for example, the colour of this garment or its trimmings often identified a wearer's banner. Centre front-opening surcoats were always tailored with vents at the centre back and sides. Beginning in 1652, a surcoat bore insignia badges that indicated an individual's rank.[13] Three-quarter length surcoats, totally faced with fur, called *duanzhao*, were used in cold weather. Eventually these luxurious garments were restricted to the nobility, imperial guardsmen, and the top three ranks of officials. The type of fur and colour of the lining were determined by rank.[14] Vests and sleeveless coats are also widely distributed among steppe nomads and inhabitants of the Tibetan plateau, but did not occur among the wardrobes of taiga hunters and fishers.

Construction features, such as loop and toggle fastenings, the curved top edge of the front overlap, or the presence of angled shoulder seams provide evidence of hide prototypes; however, the extra long tapered sleeves with flaring cuffs, which identified Qing dynasty garments as "Manchu," are eccentric.[15] Initially, the extra sleeve length of horse-riding nomads kept the hand warm when the sleeve was allowed to fall down. When it was pushed up the arm to engage the hand for riding or fighting, the distinctive horse hoof cuff, called *matixiu*, protected the back of the hand.[16] How or when these elements became part of Manchu attire is unknown. Several aspects of Manchu history from the period just prior to the conquest strongly suggest that the distinctive dress may be from a concerted effort to differentiate the Manchu as its own nationality and may have occurred rapidly with the reorganization of Manchu society into banners. This new Manchu order required uniform dress. The curved shape of the top edge of the coat front overlap and the cuffed sleeves emphatically distanced Manchu clothing from the dress of other groups, like the Mongols, who could also have made claims to the Chinese throne. From at least the thirteenth century, Mongol coats, called *degel* or *de'el,* had an asymmetrical front overlap that angled in a straight line from the centre front neck to the right underarm. While all nomadic horsemen's coats have extra long sleeves, only Manchu sleeves are fitted with separately cut and applied cuffs. These garments established a singular identity for the Qing rulers. In turn, this official "Chinese" imperial dress later influenced the garment styles worn by the Han-Chinese majority, as well as those ethnic minorities in southern China, like the Miao, Zhang and Yi and those of the northwest, like the Xibe, Dong and Du.

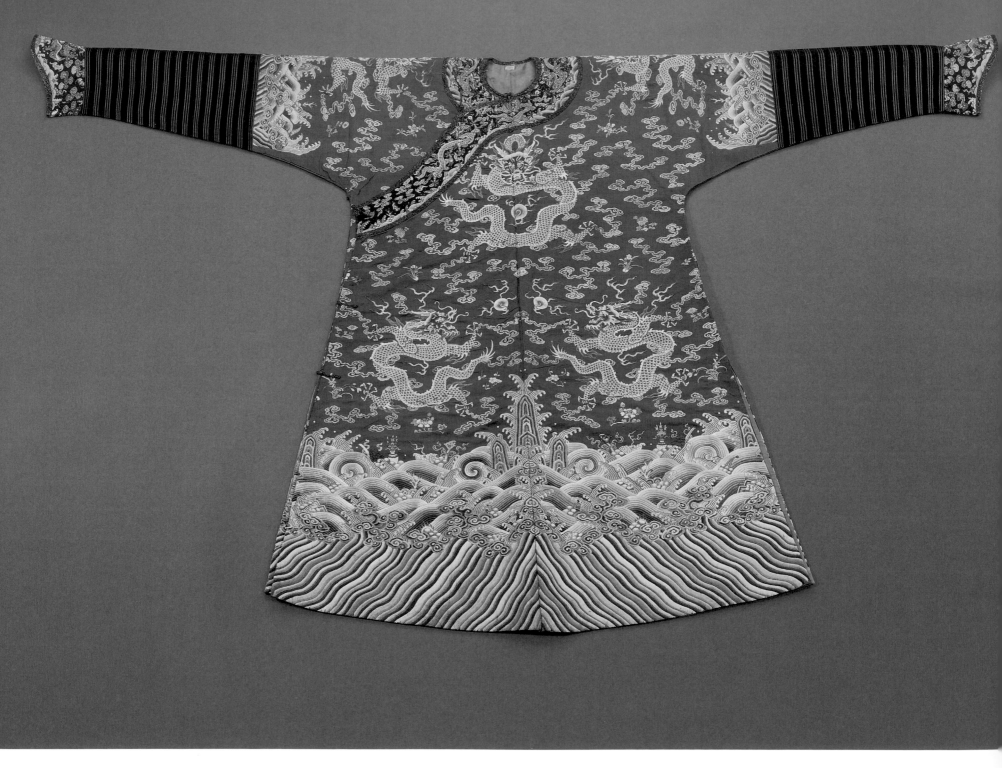

2005.5.79

Jifu, or semi-formal court robe for imperial prince.
*Silk twill embroidered with floss silk and gold-wrapped thread*
*Qing dynasty, Jiajing period (1796–1820)*
*L: 137.4 cm; W. across shoulders: 217 cm*

*Provenance: Acquired at Sotheby's, New York, sale 5011 lot 107, February 25, 1983*
*Unpublished*

All members of the imperial clan were assigned yellow court robes. The emperor and his consort were the only members of the clan to use minghuang, or "bright yellow. In order to differentiate the relationship to the emperor of other members of the imperial clan, different shades of yellow were developed. The brown ground colour of this *jifu*, known as *jinhuang*, or "golden yellow" was assigned to the emperor's sons and uncles. Contrasting facings emphasize the cut of the front overlap and shape of the flaring "horsehoof," both indicators of Manchu identity. The cuffs with their gold dragons do not match the rest of robe and were probably added to replace the worn, or damaged originals.

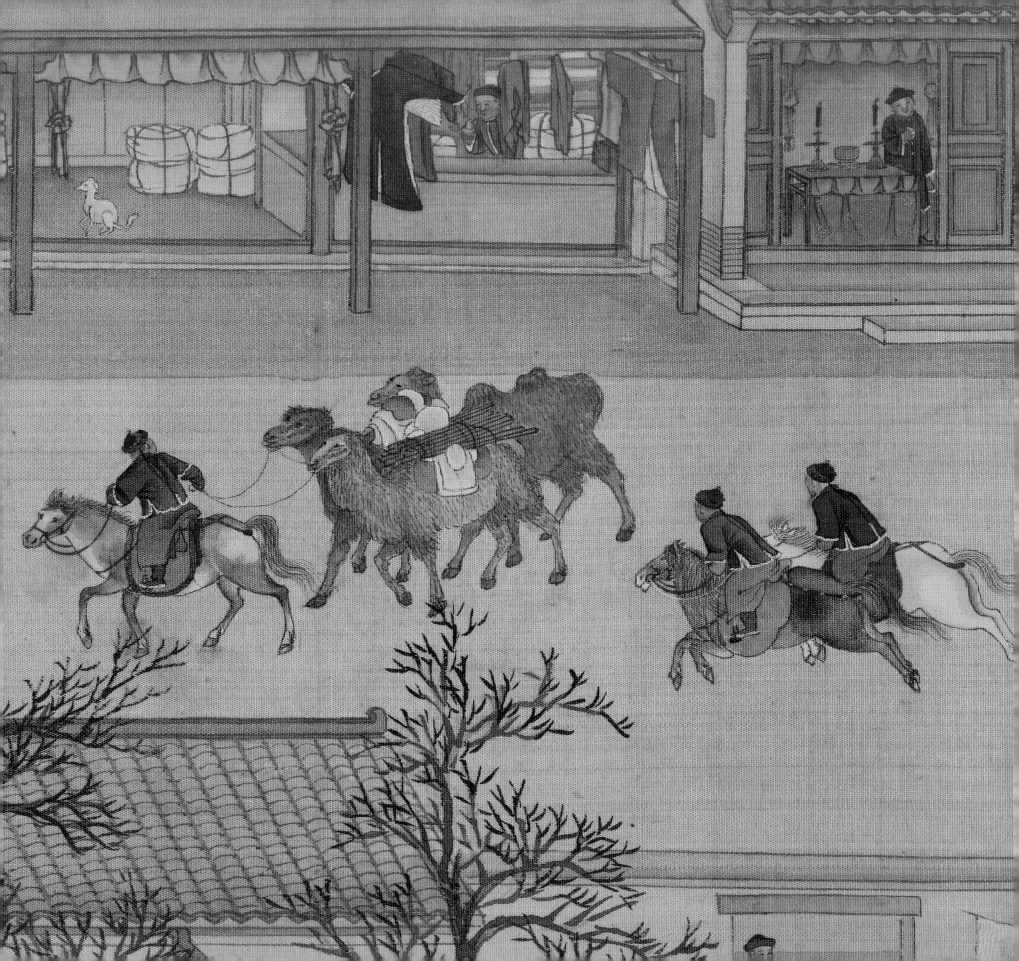

# *Designing Imperial Identity*

SHORTLY AFTER ASCENDING the Dragon throne in the fifteenth century, the Ming court attempted to engage various northern tribal groups through diplomacy. Following a long-established practice, the court attempted to buy peace along the frontier by selectively awarding patents to tribal chieftains. These conferred recognition and prestige while securing subservience to Ming dynasty rule. In recognition for paying tribute to the emperor, the Chinese court bestowed titles and dress appropriate to the ranks of these tributaries. By the sixteenth century, the Manchu were numbered among tributaries who received gifts of dragon-patterned robes and robe yardages.[17]

## Manchu Ceremonial and Ritual Attire

THESE DRAGON-PATTERNED SILKS followed a patterning formula suitable for a Chinese-style robe with long flowing sleeves and wide skirts. The Manchu, like other alien groups, adapted them to a very different construction strategy—fashioning them into formal or ritual garments that were auxiliary garments rather than independent garments. Although none of these early restyled garments survive, we can reconstruct their appearance by examining the most formal Qing dynasty court robes, called *chaopao*. These robes visually consisted of three units, preserving the appearance of horse-riding nomadic attire. The upper part was a knee-length riding coat, of which only the lower sleeves and cuffs were visible. Over the riding coat was a short sleeved, hip-length surcoat similar to the *magua*, which was worn with a belt. The third component was a pair of aprons arranged to overlap at the sides that covered leggings and boots, adding bulk that was associated with formality.

Dragon-patterned silks became so highly coveted that, much to the exasperation of the Chinese court, robes were often the subject of formal demands addressed to the Chinese emperor by various nomadic chieftains. By the late 1520s, the Chinese court attempted to curb the demands by announcing that the "northern barbarians" could no longer wear the dragon robes or buy more. For the Manchu and their Mongol neighbours the prohibition was more annoying than effective. Increasing weakness within the Ming defences emboldened northern tribal leaders to mount raids and to use blackmail to obtain

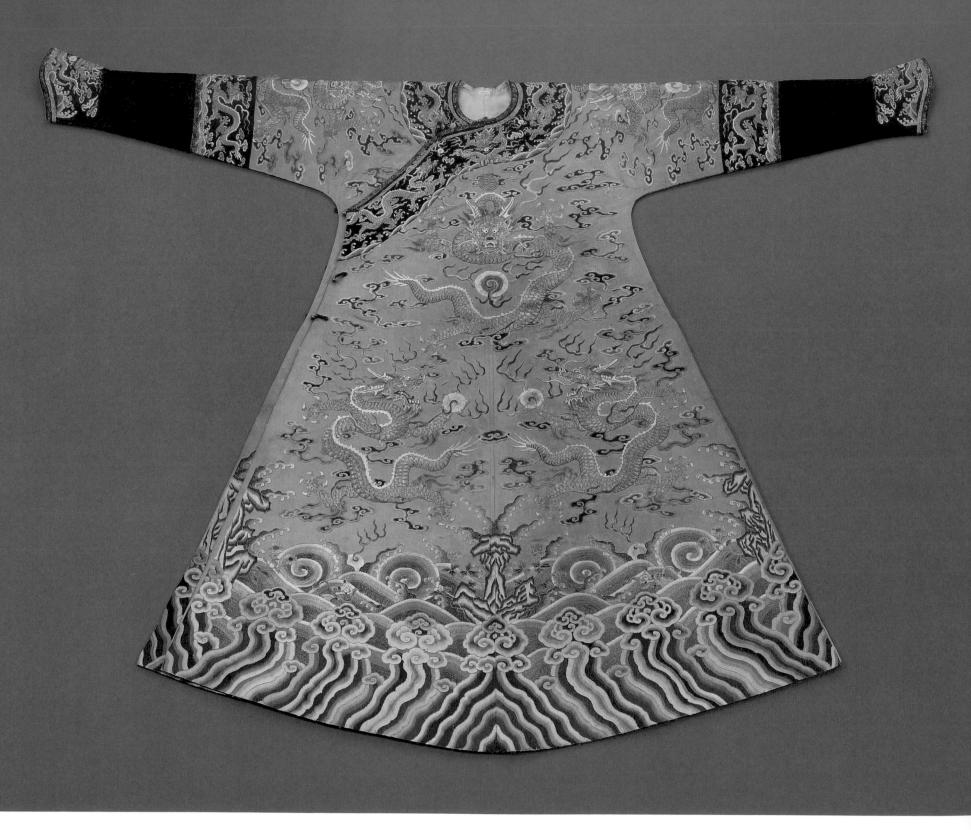

2005.5.7

*Jifu, or semi-formal court robe, first style for an imperial consort.*
*Silk satin embroidered with multi-coloured floss silk and gold-wrapped*
  *thread*
*Qing dynasty, Yongzheng or early Qianlong period (1725–1750)*
*L: 140.4 cm; W. across shoulders: 177.9 cm*

*Provenance: Spinks, London, March 20, 1985*
*Published: Dickinson and Wrigglesworth, Imperial Wardrobe, 2000, revised edition, pl.173, p.*
  *193; Vollmer, Ruling from the Dragon Throne, 2002, fig. 4.2, p. 82.*

The wardrobes of imperial women detailed in the *Huangchao liqi tushi* included the garments of the emperor's daughters and five grades of consorts. Their individual ranks were largely distinguished by the colours of the garment fabrics. This yellowish-green tone was known as *xiangsi*, or "incense colour," and was often worn by lower-ranking concubines.

The skirts of women's dragon robes have vents at the side seams, rather than at the centre front and back as prescribed for men. They also carried an additional contrasting band of decoration on the sleeves, which matched the neck facings and cuffs. Stylistically, the closest examples to this particular robe are dated to the Yongzheng period (1723–1735). One is in the Palace Museum, Beijing (see: Zhao Xiuzhen et.al., 1999, pp. 196–197 and appendix p. 25); another is in the collection of the Asian Art Museum, San Francisco (see Terese Tse Bartholomew, *Hidden Meanings in Chinese Art*, 2006, p. 253). Both examples are embroidered on yellow satin, have alterations to the sleeves and are presently styled as men's robes. Like the 2005.5.7, they feature boldly drawn angled wavy *lishui*, or standing water borders, which end in a series of five *ruyi*, or wish-granting jewel-shaped cloud heads. The standing water borders break at the sides to angle toward the rock at the side vents. Unlike those robes and others of the period, this robe does not feature a couched black cord outlining of the clouds and other details; rather, a gold-wrapped thread has been used, which is typical of embroideries dating from the Qianlong reign.

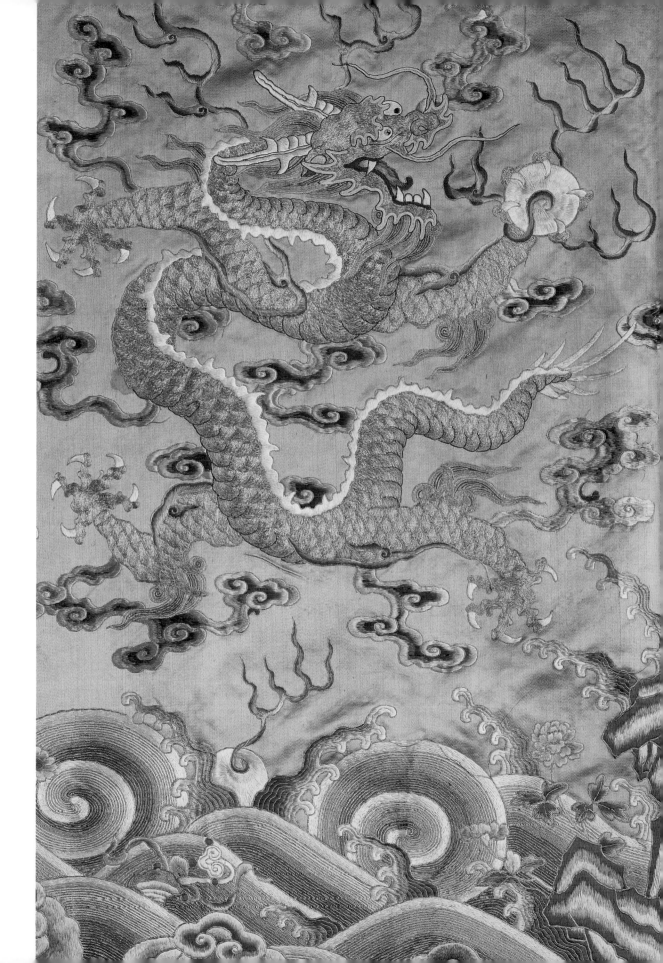

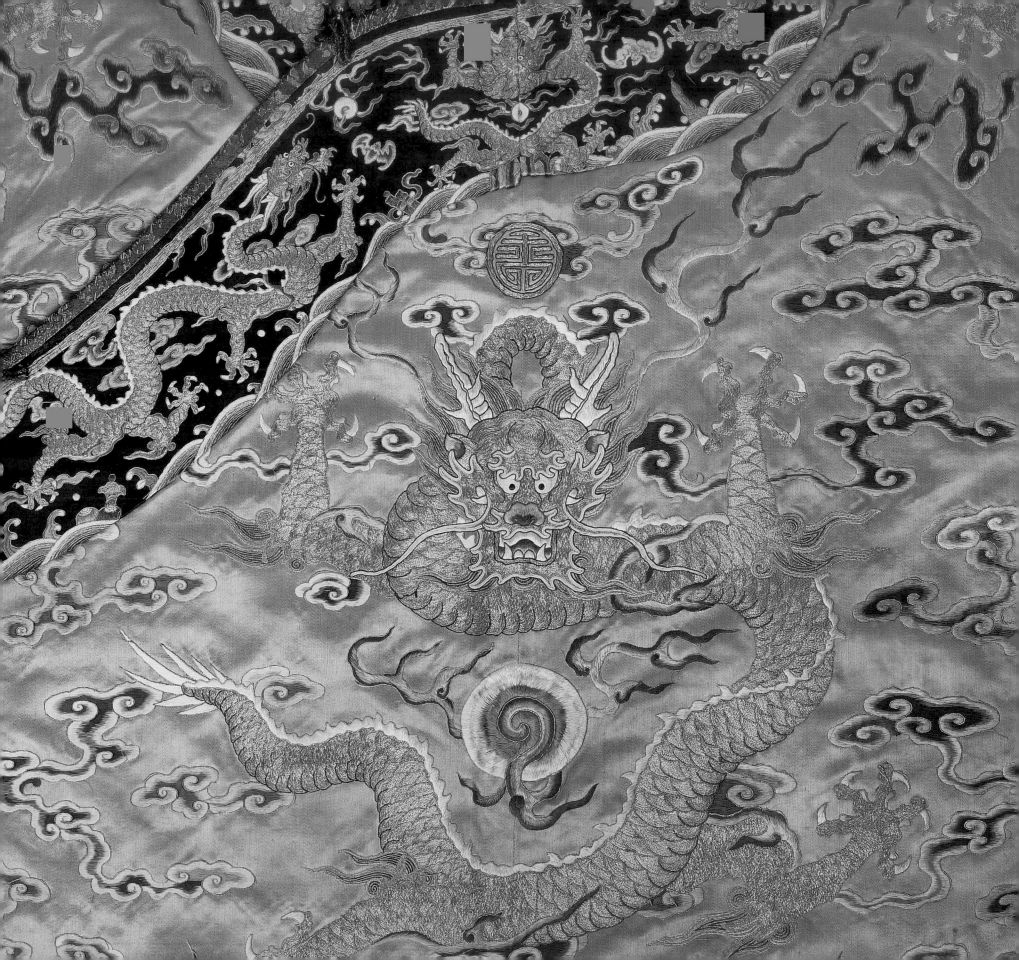

concessions, including dragon robes. Officially, Manchu tribute relations ended in 1587, but a steady northward flow of dragon-patterned fabrics continued for another half century.

### Legislating Imperial Entitlements

IN 1636, in anticipation of the conquest of the Ming empire and in imitation of Chinese imperial practice, the Manchu leader, Hongtaiji, declared a dynasty colour. This action of legitimized rule was in accordance with the ancient *wuxing,* or Five Phases Theory. Wuxing was associated with *yin/yang* philosophy and attempted to explain and correlate all human activity through the interaction of forces in nature. According to Wuxing, the five elements of the universe–water, wood, fire, earth, and metal–had a direct correspondence to seasons, directions, musical scales, and colours. The black, blue, red, yellow, and white sequence was viewed as a natural succession. Red had been the official colour of the Ming dynasty. Replacing it with yellow reflected the belief that the element earth overcomes fire.[18] The Qing government further harmonized court dress with the dynastic colour by decreeing that only the emperor and his immediate family could wear yellow robes with the five-clawed dragon called *long*. Lesser nobles were obliged to use the four-clawed *mang* dragon as legislated in 1667, unless granted the privilege of wearing the imperial symbol. Since at least the time of the Jin dynasty (1115–1234) and possibly dating back to the time of the Gaozu emperor (r. 618–626) of the Tang dynasty (618–906), wearing yellow robes had been the prerogative of the emperor, serving to link him to the mythical founder of Chinese civilization, Huang Di (the Yellow emperor). At court, the Qing heir apparent and his consort used *xinghuang* (apricot yellow), usually orange in tone; imperial princes used *jinhuang*, or golden yellow, while other members of the imperial clan used *qiuxiangsi*, or tawny yellow, which actually ranged from brown to plum tones. Manchu nobles to the rank of third degree prince used blue; all others were assigned black. These colours referred to the background colours of the garments themselves.[19]

### Rank and Status at Court

IN 1652, the Manchu enacted legislation that assigned insignia badges to all who served the emperor. The imperial court consisted of twelve grades of nobles and nine each of civil and military officials.[20] Each was assigned its own *buzi*, or badge, which was worn in pairs–one was worked on or attached to the back of the *bufu*, or court surcoat, the other was vertically divided in half at the chest of the front opening coat. The first eight ranks of nobles (the so-called Princes of the Blood) were assigned dragon badges. Distinctions were made first by the type of dragon, then by the shape of the badge. The five-clawed dragons, called *long*, marked the rank badges of the emperor and his immediate family. These outranked the four-clawed dragons, called *mang*, which were assigned to courtiers from the ranks of princes of the blood of the third through the eighth rank. Round or circular badges outranked square badges. *Long* roundels were reserved for the use of the emperor and the heir apparent, as well as the first two ranks of princes of the blood, who would have included the emperor's sons, brothers, and uncles. Princes of the blood of the third and fourth rank, the emperor's brother-in-laws and ranking clansmen, used *mang* roundels. Coats with four roundels outranked those with only two. Front-facing dragons outranked those shown in profile. Princes of the blood from the fifth through the eighth rank were assigned *mang* insignia displayed in squares. Nobles of imperial lineage from the ninth through

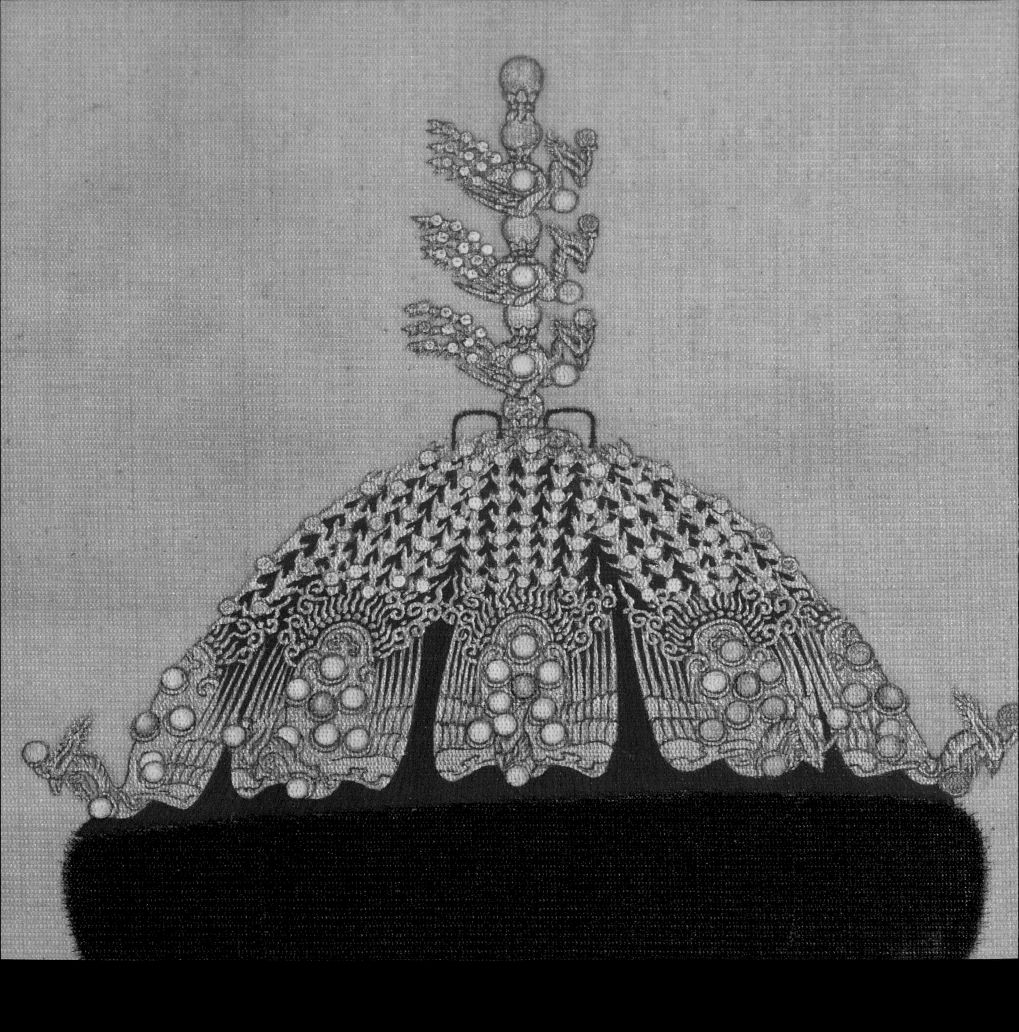

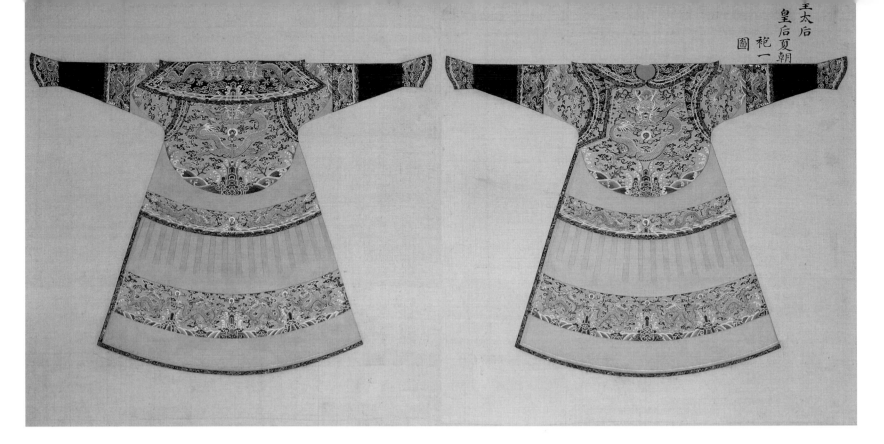

王太后
皇后夏朝
袍一
圖

2004.19.1.1.1–.68

Anonymous, *Huangchao liqi tushi*
(Illustrated Precedents of the [Qing]
Imperial Court).
*Folios from an album, ink and colour on paper
mounted on boards*
Qing dynasty, Qianlong period, ca.1759
42.2 cm x 81.6 (double leaf) cm

Provenance: 1863 Sir Thomas Phillipps, purchased at
auction from Messrs Puttick & Simpson; c.a. 1872
by bequest to grandson, Thomas FitzRoy Fenwick;
1964 acquired by Philip Robinson of London; 1988
acquired at Sotheby's London, sale "Liang", lot 36,
22 November

Published: Dickinson and Wrigglesworth, Imperial
Wardrobe, 2000 revised edition, pp. 13–29; Vollmer,
Ruling from the Dragon Throne, 2002, figs. 4.15,
4.16, and 4.17, p. 99.

In 1748 the Qianlong emperor commissioned a review of all previous dress regulations enacted during the reigns of the first three Qing dynasty (1644-1911) emperors, each of whom had modified the laws for court attire through the Neiwufu, or Office of the Imperial Household. The Qianlong review culminated in the circulation of the comprehensive set of court dress edits called the *Huangchao liqi tushi* in 1766.

The University of Alberta Mactaggart Art Collection holds 34 folios specifying the formal court wardrobe of the dowager empress, the mother of the emperor. Each is marked with dowager's title, *Huangtaiho*, at the right raised three characters above the text. Complex garments like the summer *chaopao*, or ritual court robe, first type, were show front and back (above; 2004.19.1.1.22 and .23). These were part of an estimated 6000 folios executed in full colour on silk, mounted on double boards and framed with protective paper borders. They were personally reviewed by the emperor in 1759 before the publication of woodcut illustrated editions which were circulated throughout the land. The leaf illustrating the winter hat (Detail at the left: 2004.19.1.1.63) bears an impression of the *Qianlong zhengshang seal* ("Qianlong has appreciated") probably applied at the time of the first viewing. Two other leaves of the folio bear impres-

sions of official seals. One, the *Yuanmingyuan bao* seal (Treasure of the Yuanmingyuan) suggests the folios were kept at the imperial summer palace, a fact noted in the first sales description in 1863. The second seal is the *Wufu wudaitang guxi tianzi bao* seal (Treasure of the Septuagenary Son of Heaven and the Five Generation in the Hall Five Happinesses) a reference to Qianlong's seventieth birthday in 1781, when he presumably examined some of these folios again, having received congratulations from five generations of imperial family.

The reverse of the right hand opening of most folios in the collection is marked with Chinese numerals. These read 13.1 on the reverse of the dowager empress's winter court hat, 13.2 on the reverse of the text describing it, and so forth. The only other folio for a garment appropriate for an empress or the dowager empress is in the British Library and bears the number 14.21. It has been estimated that a total of 20 volumes were required for the costume section, each with approximately 30 folios. It can be assumed that earlier volumes dealt with the dress of the emperor and other imperial males. Volumes 13, 14 and 15 dealt respectively with the formal dress of the Empress Dowager, the less formal attire of the empresses and the dress of secondary consorts.

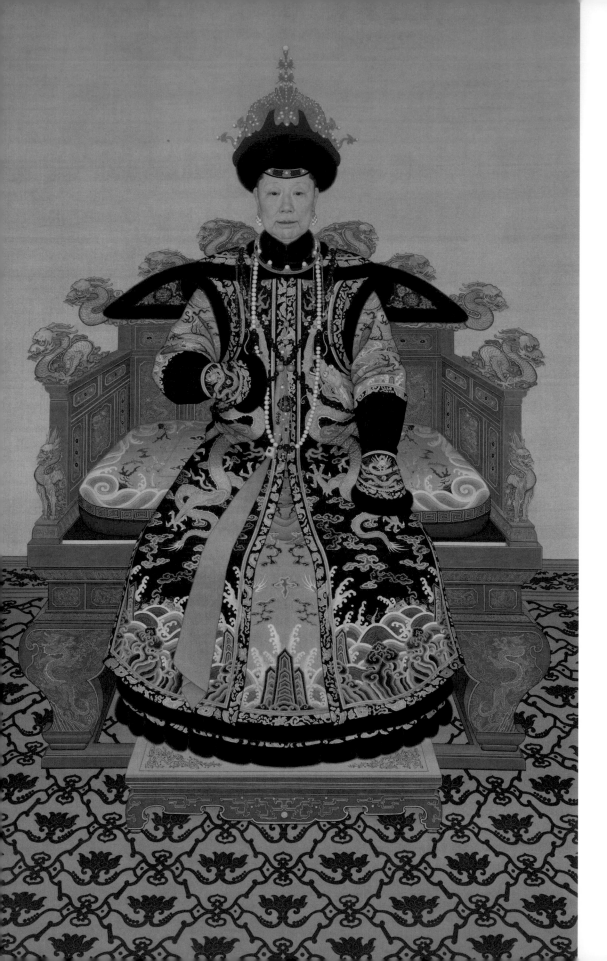

This portrait of Xiaosheng Empress Dowager (1692–1777), the Qianlong emperor's mother, was painted for her sixtieth birthday. She wears the most formal court garments called *chaofu* with sable edgings for winter. Although unattributed, the portrait's realism reflects the influence of the Jesuit painter Giuseppe Castiglione (1688–1766), who served the Qing dynasty court. He is credited with introducing Western style shading and one-point perspective to the imperial painting academy.

*Anonymous, the Xiaosheng empress, dated 1751. Hanging scroll: ink and colours on silk; 230.5 cm x 141.3 cm. Palace Museum, Bejing, Gu6452. © Palace Museum, Beijing*

2004.19.1.1.3
*Chaoqun*, or formal winter court petticoat, for Empress Dowager.

2004.19.1.1.15
*Chaopao*, or formal winter court robe, third style, for Empress Dowager.

2004.19.1.1.39
*Chaogua*, or formal court vest, third style, for Empress Dowager.

2004.19.1.1.7
*Zaishui*, or court ceremonial kerchief, for Empress Dowager.

2004.19.1.1.63
*Chaoguan*, or formal winter court hat or crown, for Empress Dowager.

2004.19.1.1.15
*Jinyu*, or court diadem or headband, for Empress Dowager.

2004.19.1.1.9
*Chaozhu*, or court necklaces, for Empress Dowager.

2004.19.1.1.11
*Lingyue*, or court torque, for Empress Dowager.

2004.19.1.1.53
*Ershi*, or triple set of court earrings, for Empress Dowager.

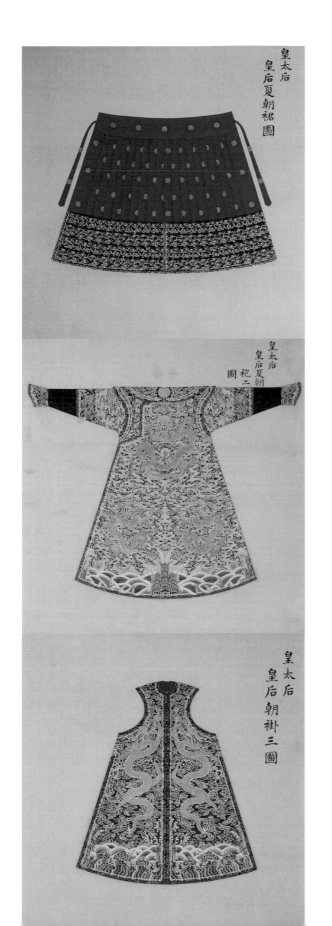

皇太后皇后夏朝裙圖

皇太后皇后夏朝袍二圖

皇太后皇后朝褂三圖

皇太后皇后綵帨圖

皇太后皇后冬朝冠圖

皇太后皇后金約圖

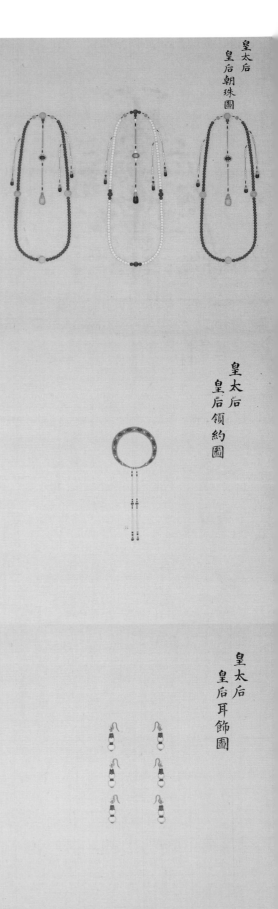

皇太后皇后朝珠圖

皇太后皇后領約圖

皇太后皇后耳飾圖

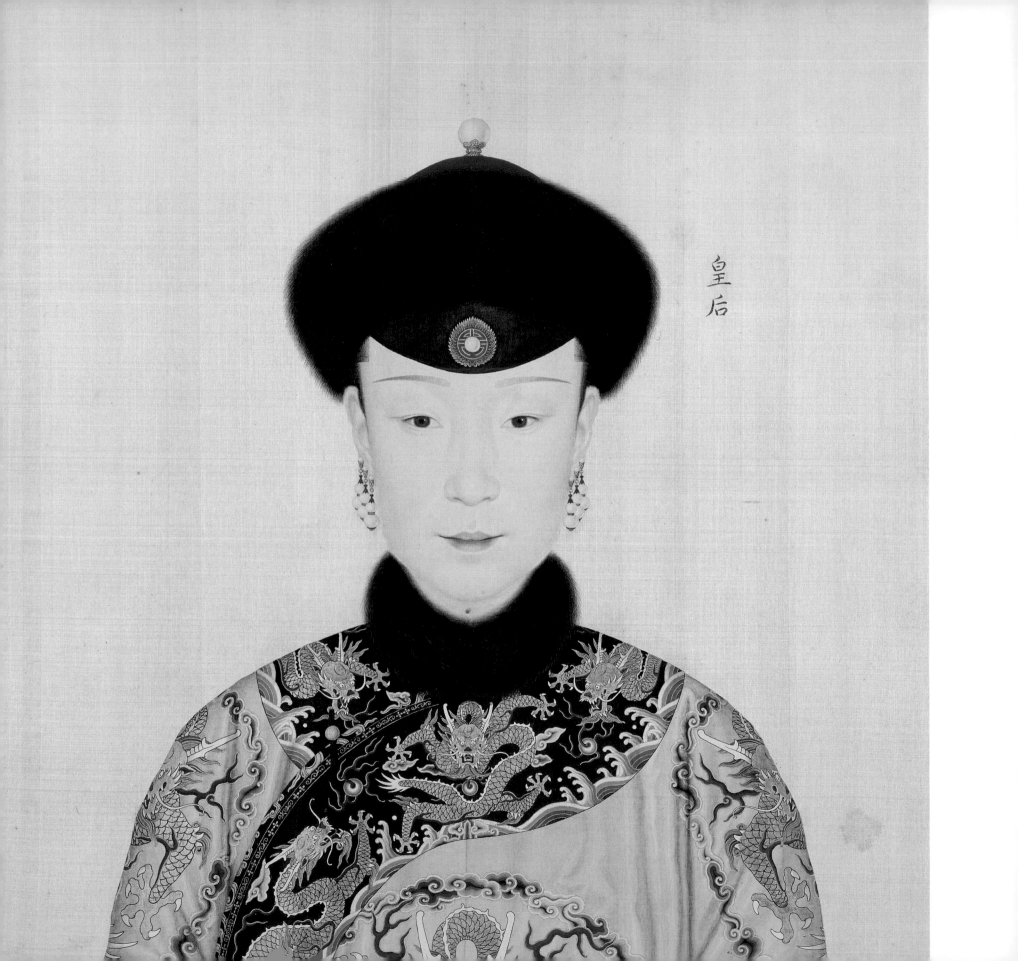

皇后

the twelfth rank and all military officers were assigned squares with animal insignia. Birds indicated the nine classes of civil officials.

Rank badges were based on Ming dynasty precedent. Adopting them bolstered the legitimacy of the Manchu ruling house and stressed imperial continuity. While this action followed a Chinese precedent, it was in fact linked to the Mongol Yuan dynasty practice of wearing decorated surcoats and to Mongol predecessors, the Jurched, who ruled northern China in the twelfth century under the Jin dynasty. Ming badges had been applied directly to court robes, but the Manchu applied them at the chest and back of a plain dark coloured unbelted surcoat with uncuffed elbow length sleeves in keeping with their image as nomadic conquerors. For men, the coat was mid-calf length, leaving the long cuffed sleeves and decorated hem of the dragon-patterned robes exposed. Manchu women, in contrast, wore full-length surcoats.[21]

## Creating Imperial Wardrobe

AS EMPERORS, the Manchu embraced the Confucian notion that court apparel defined and sustained the elite who were responsible for good government on earth and harmony in heaven. Traditional Manchu wardrobe simply included either occupational dress or specialized ritual wear. Once installed in Beijing, the Manchu three-part ceremonial robe was elevated to the status of *chaofu*, or court attire, and its use was restricted to the most important court functions. Notably, whole categories of official semiformal and informal attire were missing from the Manchu wardrobe.

Every activity undertaken by the emperor—whether it was witnessed by hundreds of people during annual state sacrifices, grand audiences and imperial birthday celebrations, or private readings and studying texts, visiting the imperial mother and instructing the imperial children—was in fact an official event that required appropriate dress.[23] Initially, various Ming-style garments were adapted for these purposes; however, the Manchu imperial image remained incomplete until 1766, when legislation and proclamation classified all clothing and accessories used by the court.

## Huangchao liqi tushi Edicts

ONE THE MOST SIGNIFICANT OBJECTS in the Mactaggart Art Collection is a set of 34 folios illustrating the formal garments and accessories, which were classified as *chaofu*, assigned to the dowager empress, mother of the emperor. These documents were executed in full colour on silk, mounted on boards and framed with protective paper borders for the emperor's inspection. Originally numbering over 6,000 folios, they were part of a cache seized from the imperial summer palace at Yuan Ming Yuan in 1860 when it was pillaged and razed by combined French and English forces under John Bruce and Lord Elgin (1811–1863). This punitive action was in retaliation for the Chinese imperial government's failure to pay imposed indemnities after its defeat in the first Opium War of 1842. Plundered goods, including textiles and costumes unlike anything seen before, quickly entered European art markets.

The English bibliophile Sir Thomas Phillipps (1792–1872) acquired the folios at a London auction in 1863. They remained in the Phillipps Library, which was passed to his grandson, Thomas FitzRoy Fenwick (1856–1938), until it was sold to the London book dealers Lionel and Philip Robinson in the 1960s. In 1988, the folios were acquired by the Mactaggarts at auction from Sotheby's, London. They bear impressions of large square seals inscribed "Treasure of the Yuanmingyuan" and "Treasure of the Septuagenary

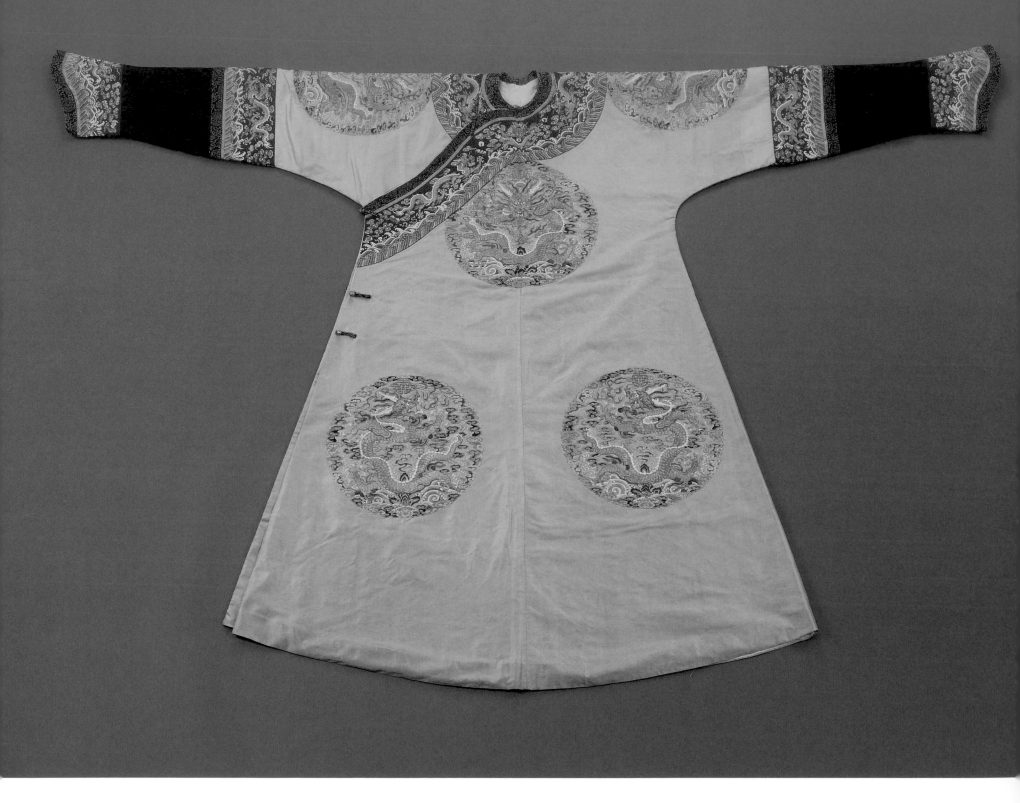

2005.5.9

*Jifu*, or semi-formal court robe, third style for empress.
*Silk satin embroidered with multicoloured floss silk and*
*    gold-wrapped thread*
*Qing dynasty, late Qianlong period (1775–1795)*
*L: 135 cm; W. across shoulders: 197.5 cm*

*Provenance: Linda Wrigglesworth, London, April 21, 1986*
*Published: Dickinson and Wrigglesworth, Imperial Wardrobe, 2000, revised edition, pl.*
*    176, p. 195; Vollmer, Ruling from the Dragon Throne, 2002, fig. 4.9, p. 92.*

The *Huangchao liqi tushi* authorized three styles of semi-formal
attire for the empress and other high-ranking women of
the court. The first style was nearly identical to the *jifu*, also
called *longpao*, or dragon robe, for the emperor, which has a
single integrated design of dragons within the cosmos across
the entire surface of the coat. The second type confined the
dragons to nine roundels. Eight were exposed and the ninth
roundel was placed under the front overlap, above a *lishui*,
or "standing water," border. The third type, such as this
example, is decorated with nine roundels only.

Dragon roundel robes are familiar from Inauguration
portrait of the Qianlong emperor, his empress and his ten
consorts. All of the imperial women are wearing them. Only
two examples of the eighteenth-century roundel robes survive:
2005.5.9 and a second type with *lishui* border in the Danish
National Museum, Copenhagen (acc. no. Bd 207). Both are
embroidered on yellow silk satin with multicolour floss silk
and gold-wrapped threads and closely resemble to the work
depicted on Castigilione's 1736 portraits. The Palace Museum,
Beijing, Collection has published a number of dragon roundel
robes in its collection. They include men's robes of the late
seventeenth and early eighteenth century (Palace Museum,
Beijing, 2005, pls. 29, 32, and 33, which are all attributed to
emperors; and 90 for an empress). All other dragon roundel
robes for imperial women date from the nineteenth century
(see: Ibid., pls. 106, 107, and 111).

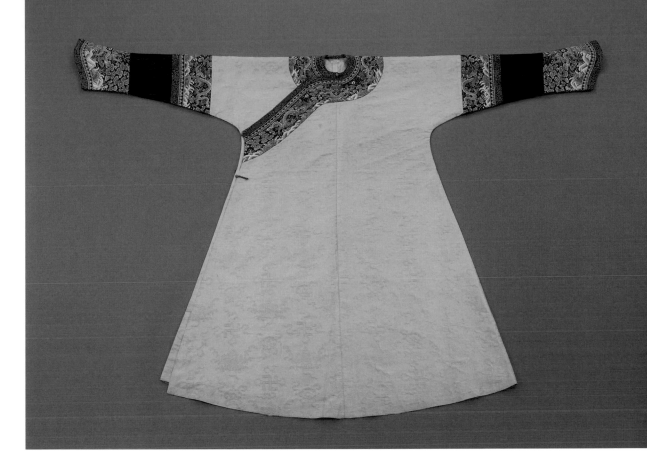

2005.5.10

*Changfu*, or informal court robe for empress.
*Silk damask with embroidered silk twill facings and cuffs*
*Qing dynasty, probably Jiaqing period (1796-1820)*
*L: 138.6 cm.; W. across shoulders: 196 cm.*

*Provenance: Acquired at Liberty's, London, June 1, 1986*
*Unpublished*

Although classified as informal wear, *changfu* were an important
component of the official wardrobes of the Qing court. Whether
worn to visit other members of the court or between official
functions, such garments were still expected to communicate
information about status and rank. Because they were not being
worn for official business involving the political responsibilities
of the court, *changfu* were ornamented with dragons. *Changfu*
rarely survive and are often difficult to identify.

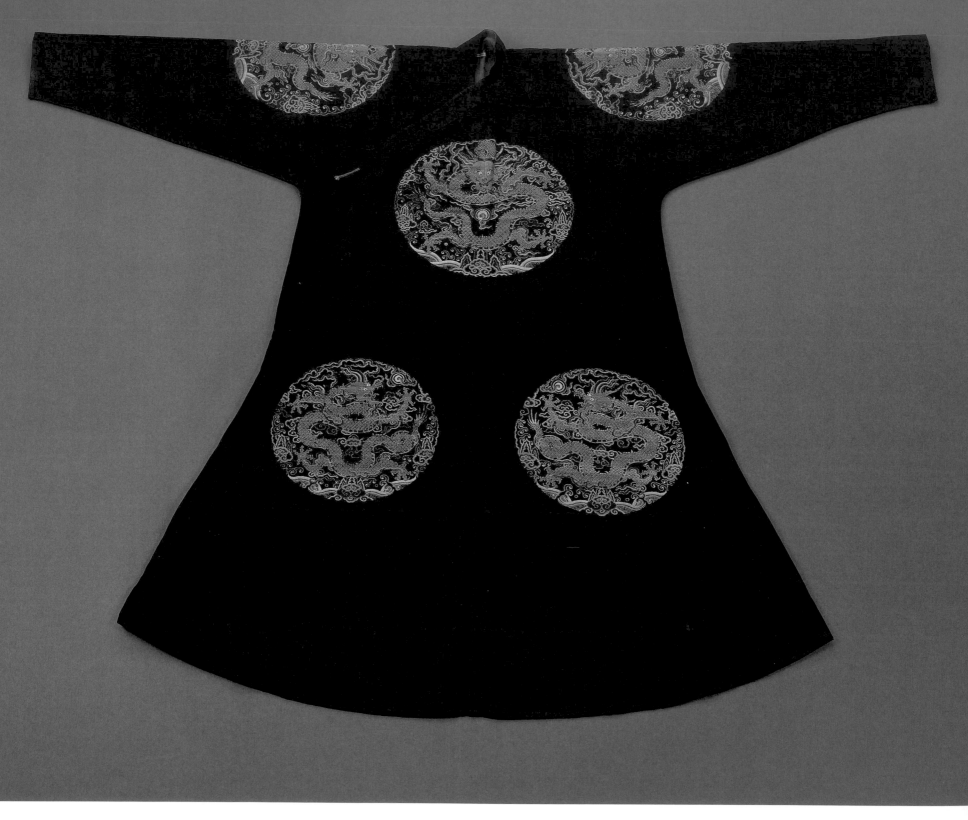

2005.5.107

*Chuba*, or robe for an aristocratic man.
Made from empress *longgua*, or court
   surcoat, for an empress.
Silk damask brocaded with floss silk and
   gold-wrapped threads
Tibetan, made of Chinese silk, Qing dynasty,
   mid-Qianlong period (1750–1775)
L: 142.4 cm; W. across shoulders: 183.9 cm

Provenance: Steven McGuinness, Hong Kong,
   December 12, 1986
Unpublished

This mid-eighteenth century empress's
*longgua*, which had been once been
made up and presumably worn at court,
survives because at a later date it was
sent to Tibet. It is possible this garment
was made for the Xiaoxian empress
(1712–1748), but remained unused
and after her death was stored in the
Forbidden City, where it was selected to
form part of an imperial gift to Tibet's
political and religious leaders. Eventually
it was retailored in Tibet to conform
to local aristocratic fashions. The area
under the arms was expanded with an
infill of navy blue satin; the centre front
opening was closed and an angled front
overlap was constructed. Nonetheless,
the basic form of the Qing dynasty
empress's surcoat is clearly visible.

In its Qing court context, this
floor-length over garment would have
completely obscured the design of a
semi-formal court robe like no. 2 above.
While the highly detailed cosmic imagery
was philosophically important to the
Manchu, the surcoat emblazoned with
insignia indicating rank was essential for
the orderly running of government.

Son of Heaven and the Five Generations in the Hall
of Five Happinesses," a reference to the Qianlong
emperor's seventieth birthday in 1781. Additionally,
there is a label "18054," Sir Thomas's inventory
number. Other folios from the *Huangchao liqi tushi*
presentation set had been acquired by the Victoria
and Albert Museum at auction in London in 1895.
These 290 folios were divided among the Victoria and
Albert Museum, the Royal Scottish Museum and the
Dublin Museum of Art, now the National Museum
of Ireland. In 1900, the Victoria and Albert Museum
purchased a second lot of 72 folios and in 1904 it
acquired 53 more. A further 128 folios were acquired
in 1953. The British Library received a donation of 33
folios in 1926.[24] In total, all of the folios, including
those in the Mactaggart Art Collection, number 610,
approximately ten percent of the estimated original
commission.

These folios are the culmination of a decade-long
review of court dress commissioned by the Qianlong
emperor in 1748. The commission was headed by
Prince Zhuang (1695–1767), uncle of the emperor
who been one of Qianlong's tutors. Other members
included the president of the Board of Rites, editors
from five other government boards, seven compilers
from the Hanlin Academy, a chief writer with a staff
of eight copyists, and at least four artists. The com-
mission was ordered to examine all previous dress
regulations enacted during the reigns of the first
three Qing dynasty emperors and to develop a new
comprehensive strategy. The illustrated catalogue of
all of the ceremonial trappings of the imperial court
was presented to the emperor in 1759. Promulgation
of the edict in a woodcut-illustrated edition occurred
in 1766.

On one level, the edicts affirmed the determina-
tion of the Manchu conqueror to resist increasing

pressure to restore native Chinese dress. The reasons
are eloquently summarized in the emperor's preface:

> *...We, accordingly, have followed the old traditions
> of Our dynasty, and have not dared to change them
> fearing that later men would hold Us responsible for
> this, and criticize Us regarding the robes and hats;
> and thus We would offend Our ancestors. This We cer-
> tainly should not do. Moreover, as for the Northern
> Wei, the Liao and the Jin, as well as the Yuan, all of
> which changed to Chinese robes and hats, they all
> died out within one generation [of abandoning their
> native dress]. Those of Our sons and grandsons who
> would take Our will as their will shall certainly not
> be deceived by idle talk. In this way the continuing
> Mandate of Our dynasty will receive the protections of
> Heaven for ten thousand years. Do not change Our tra-
> ditions or reject them. Beware! Take warning!*[25]

Seemingly, the *Huangchao liqi tushi* dress edict was
concerned with preserving Manchu style clothing,
and with it Manchu identity. Some garment features,
like the shaped overlap at the front and the sleeve
extensions with horse hoof cuffs, continued Manchu
forms and construction details. But in general, the
restyling reflected Chinese tastes and the efforts of
the Office of the Imperial Household to transform
the image of the Manchu sovereign from barbarian
chieftain to the emperor of a Confucian Chinese
state. This legislation effectively merged notions of
ethnic nationality and separation with concepts of
cosmic purpose and centralized control.

| Male Rank | Insignia | Corresponding Female Rank | Insignia |
|---|---|---|---|
| **Emperor** (*Huangdi*) | 4 roundels: frontal *long* with sun and moon on shoulders | **Empress Dowager** (*Huangtaihou*) | 2 styles with 8 roundels: 4 frontal *long* and 4 profile *long* |
| **Heir apparent** (*Huangtaizi*) | 4 roundels: frontal *long* | **Empress** (*Huanghou*) | 2 styles with 8 roundels: 4 frontal *long* and 4 profile *long* |
| **Imperial sons** (*Huangzi*) | 4 roundels: frontal *long* | **Consort, first rank** (*Huangguifei*) | 8 roundels: 4 frontal *long* and 4 profile *long* |
| **Prince of the blood, first rank** (*Heshe qinwang*) | 4 roundels: frontal *long* at chest and back; profile *long* at shoulders | **Consort, second rank** (*Guifei*) | 8 roundels: 4 frontal *long* and 4 profile *long* |
| **Prince of the blood, second rank** (*Dolo junwang*) | 4 roundels: profile *long* | No corresponding female rank | |
| **Prince of the blood, third rank** (*Dolo beile*) | 2 roundels: frontal *mang* | **Consort, third rank** (*Fei*) | 8 roundels: 4 frontal *long* and 4 profile *gui long* |
| **Prince of the blood, fourth rank** (*Gushan beizi*) | 2 roundels: profile *mang* | No corresponding female rank | |
| **Prince of the blood, fifth rank** (*Fengen zhenguo gong*) | 2 squares: frontal *mang* | **Consort, fourth rank** (*Pin*) | 8 roundels: 4 frontal *long* and 4 profile *gui long* |
| **Prince of the blood, sixth rank** (*Fengen fuguo gong*) | 2 squares: frontal *mang* | No corresponding female rank | |
| **Prince of the blood, seventh rank** (*Buru bafen zhenguo gong*) | 2 squares: frontal *mang* | **Consort, fifth rank** (*Guiren*) | 8 roundels: 4 frontal *long* and 4 profile *gui long* |
| **Prince of the blood, eighth rank** (*Buru bafen fugou gong*) | 2 squares: frontal *mang* | No corresponding female rank | |
| **Noble of imperial lineage, ninth rank** (*Zhenguo jiangjun*), **grades one through three** | 2 squares: *qilin* | No corresponding female rank | |
| **Noble of imperial lineage, tenth rank** (*Fuguo jiangjun*), **grades one through three** | 2 squares: lion | No corresponding female rank | |

| Male Rank | Insignia | Corresponding Female Rank | Insignia |
|---|---|---|---|
| **Noble of imperial lineage, eleventh rank** (Feng-guo jiangjun), **grades one through three** | 2 squares: leopard | No corresponding female rank | |
| **Noble of imperial lineage, twelfth rank** (Fengen jiangjun) | 2 squares: tiger | No corresponding female rank | |
| **Officials, first through third ranks** | 2 squares: first civil-crane; first military-qilin; second civil-golden pheasant; second military-lion; third civil-peacock; third military-leopard | **Wife of the heir apparent** | 8 roundels: 4 frontal long and 4 profile long |
| **Officials, fourth through sixth ranks** | 2 squares: fourth civil-wild goose; fourth military-tiger; fifth civil-silver pheasant; fifth military-bear; sixth civil-egret; sixth military-panther | **Wives and daughters of imperial sons and princes of the blood, first and second rank. Princesses, first and second rank** | 4 roundels to match badges of husband's coat |
| **Officials of the seventh through ninth ranks** | 2 squares: seventh civil-Mandarin duck; seventh and eighth military-rhinoceros; eighth civil-quail; ninth civil-paradise flycatcher; ninth military-sea horse | **Wives and daughters of other princes of the blood, nobles and officials, first through third ranks** | 2 roundels or squares to match badges of husband or father's surcoat |
| No corresponding male rank | | **Wives and daughters of officials, fourth through seventh ranks** | 2 squares to match badges of husband or father's surcoat |

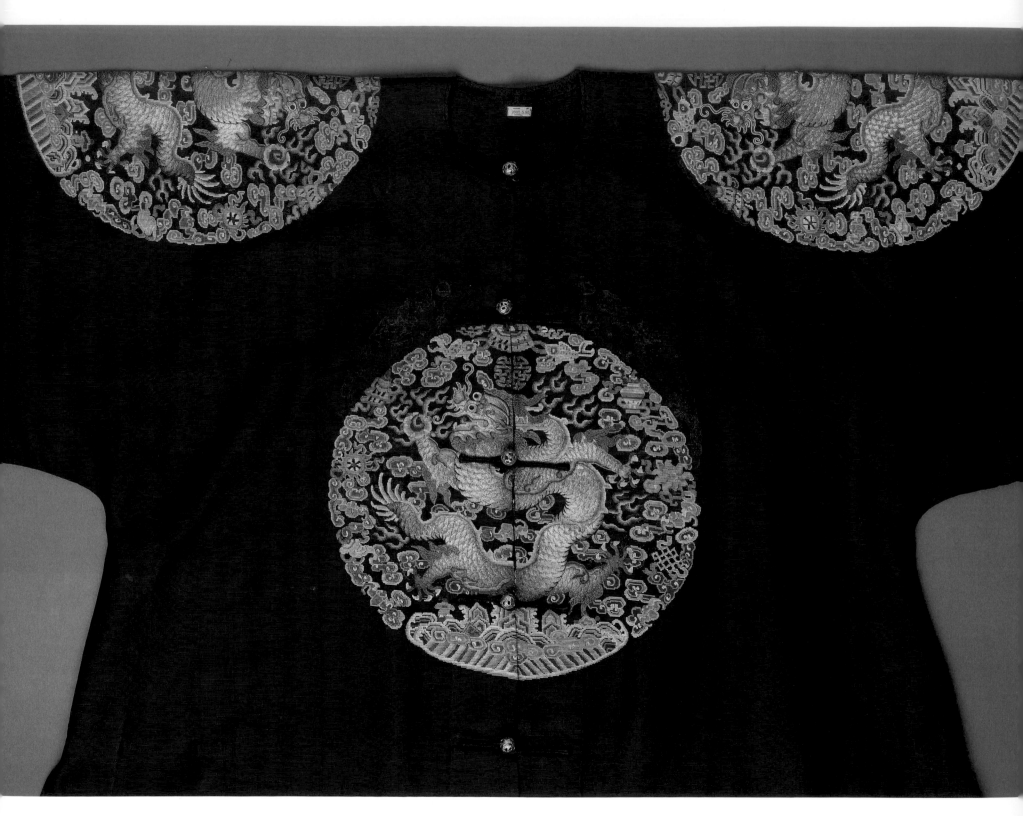

The civil and military bureaucracies were staffed by nine grades of officials and officers. Their surcoats were emblazoned with square badges. Birds indicated civilian and animals indicated military rank.

*Left:* Four round *long*, or five-clawed dragon, badges indicated the five highest noble male ranks at court. Front-facing dragons outranked profile, or walking dragons like these that emblazoned the surcoats of second rank princes of the blood, which included the emperor's brothers and uncles.

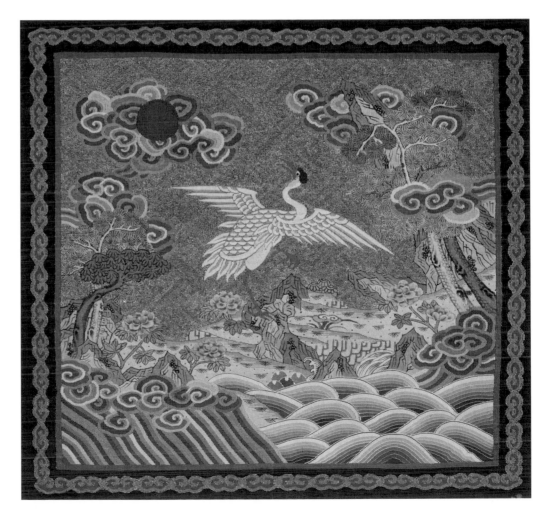

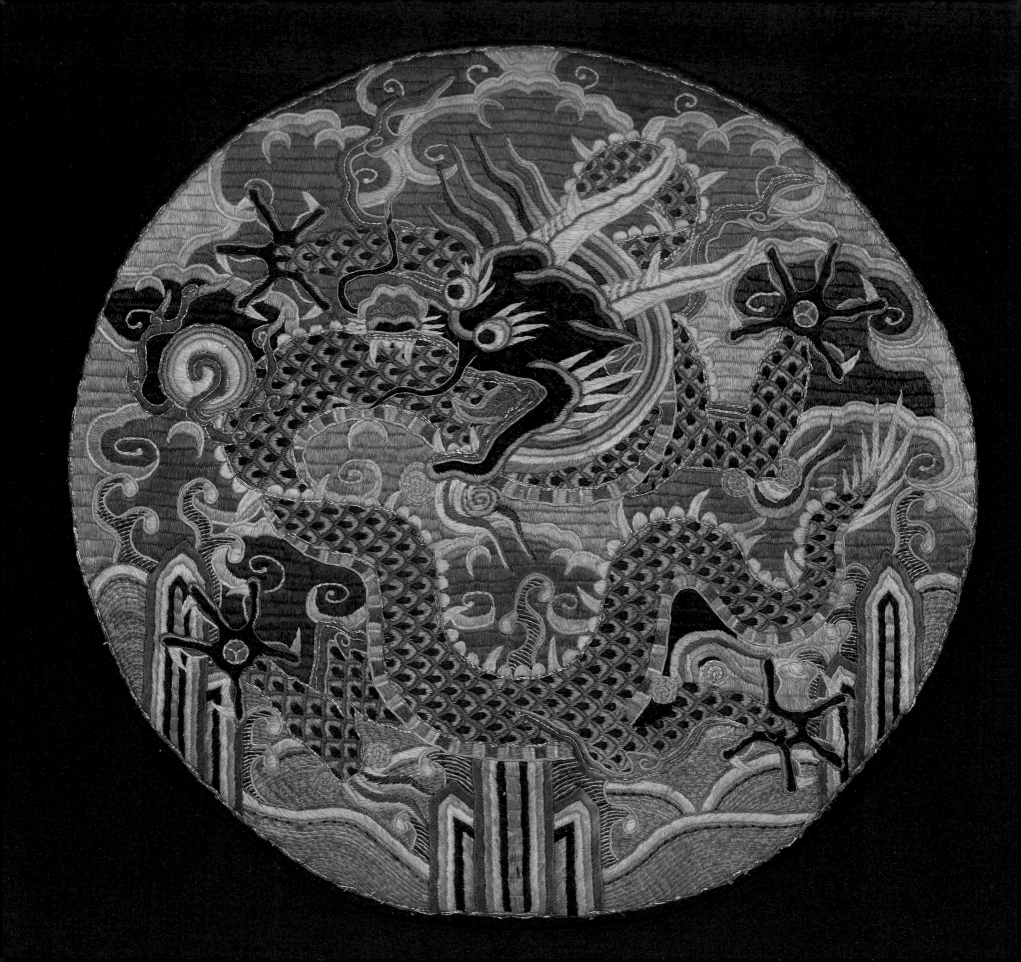

# Imperial Symbols and Dragon-Patterned Robes

**Imperial Iconography**

SINCE THE HAN DYNASTY, dragons had decorated objects used by the imperial household, as well as objects used by those representing imperial authority. However, their appearance on garments can only be documented from the Tang dynasty (618–960) when in 694 the infamous Empress Wu (r. 684–705) presented robes to court officials above the third rank. The robes had patterns appropriate to the status of the recipient. Princes received robes with deer or coiled dragons. The dragons are described in these records as having three claws. A painting from the central Asian Buddhist cave site of Dunhuang, in present-day Gansu province, depicts the emperor of the Xixia kingdom (a Tibetan dynasty, 1032–1227) wearing a coat with dragon roundels. The oldest surviving dragon robe fragment dates from the late-tenth or eleventh century and is attributed to the Liao dynasty (916–1125). Like the Xixia emperor's robe, it is ornamented with dragon roundels.[26] The Jurchen Jin also used dragon roundels to indicate status.[27]

Court robes of the Yuan imperial family displayed large-scale five-clawed long dragons. In the yoke decor, dragon bodies looped over the shoulders, their heads appearing on the chest and back, while a band on the skirt featured smaller running dragons. Although early Ming emperors restored the cut of the Tang-Song dynasty dress in a gesture to re-establish links with the indigenous Chinese tradition, they retained the Yuan decorative schemes for dragon robes.

**Ordering the Universe**

YUAN DYNASTY DRAGONS, like previous representations, were shown chasing flaming pearls among clouds. In the early-sixteenth century, Ming pattern designers added waves breaking against rocks along the lower edges of the decorative areas, creating a cosmic landscape for imperial dragons. By the end of the century, Ming weavers and embroiderers were freely experimenting with the size and placement of dragon images, but not the significance of its iconography. They eliminated all non-patterned areas to create a single decorative field for very large dragons, which were unwound from the shoulders and unfurled full-length on the front and back of spectacular robes.

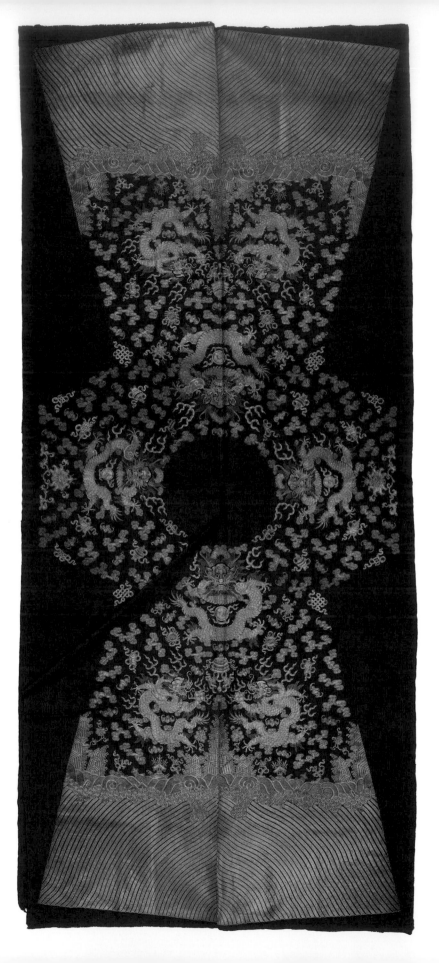

The Qing inherited these bold Ming dynasty dragons styles, but by the end of the seventeenth century, another process of rethinking the imagery of dragon robes began to emphasize a vision of the emperor's centrality within the cosmos and the purpose of imperial government. From the early-eighteenth century, Manchu dragon robes displayed a design of nine dragons, four radiating from the neck on the chest, back, and shoulders, which pointed to the direction of the cardinal points on the compass when a courtier was aligned with the axial organization of the Forbidden City. Four additional dragons on the skirts—two at the front and two at the back—indicated the intermediate directions. A ninth dragon, unseen, was placed on the inner flap. This pattern organization embodied an ancient concept of ideal land division, as envisioned by Confucius, called the *qingtien*, or well-field system. The name *qingtien* derives from the character for wellhead—a pair of horizontal lines crossing a pair of verticals, marking off nine sections symbolizing an idealized relationship between working farmers and the lord who owned the land. The eight fields protected the ninth by encircling it. Those sharing contiguous borders with the central field, if viewed as occupying the cardinal points of the compass, established the harmonious balance implied by the ancient *wuxing* (Five Elements) system, which organized Chinese thinking about the cosmos. These four created a protective ring and provided the first line of defence

Qing semi-formal court robe yardages were decorated with a mandala-like diagram of the cosmos, which when tailored into a robe literally transformed its wearer into the emperor's agent for establishing harmony between heaven and earth.

*Jifu, or semi-formal court robe, yardage; 1875–1900. Silk twill with couched gold-wrapped threads; 300 cm. x 129.8 cm. University of Alberta Museums, Mactaggart Art Collection 2005.5.114. © 2007 University of Alberta*

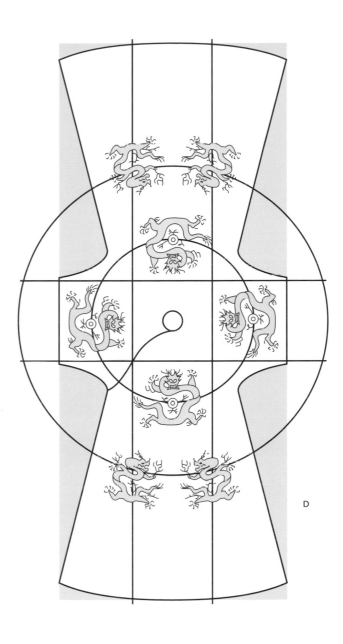

The character *jing*, meaning "well," depicts two pairs of beams marking a wellhead (a). This form was envisioned by Confucian philosophers as the most equitable means of land division. Ideally, eight farmers occupied the outer fields and shared in the farming of the central field for the lord (b). In effect, they created two rings of defence protecting the inner field (c). Manchu court coat decoration (d) reflected these notions of centrality and power. The semi-formal court coat was literally a *mandala*, or schematic diagram, representing the universe. The symbolism was complete only when the coat was worn. The human body became the world's axis: the neck opening, the gate of heaven, or apex of the universe, separated the material world of the coat from the realm of the spiritual represented by the wearer's head.

*Drawing by Richard Sheppard*

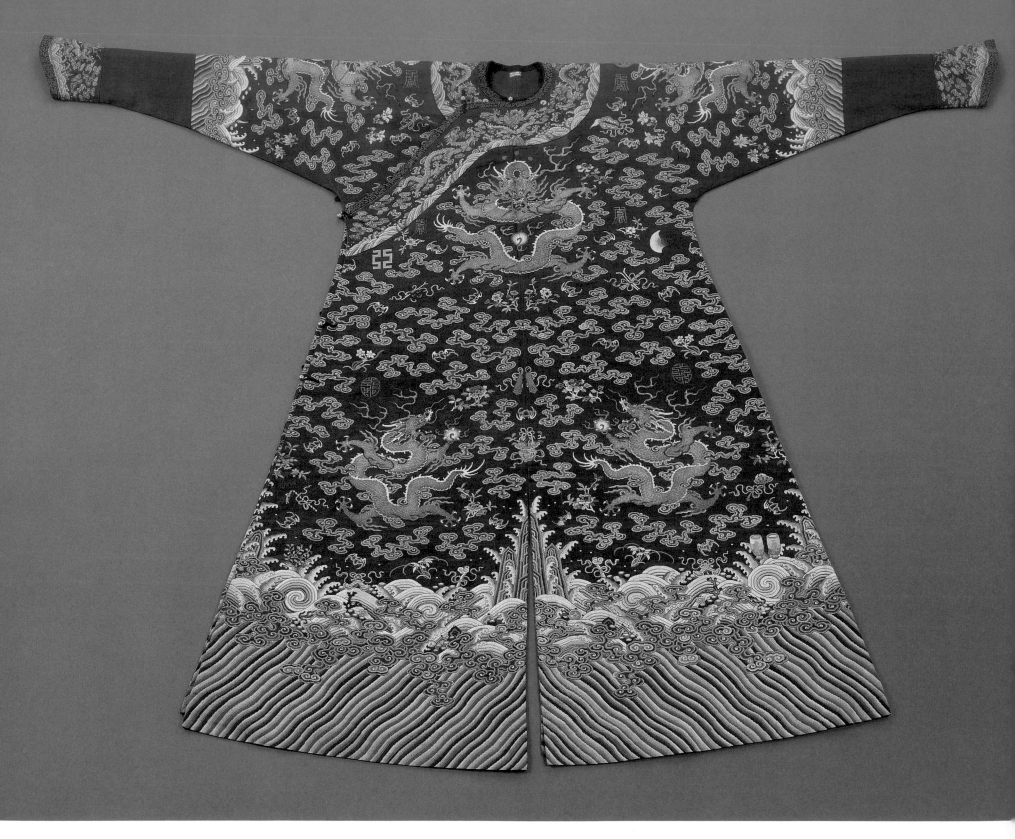

2005.5.625

12-symbol *jifu*, or semi-formal court robe for emperor.
*Silk gauze embroidered with floss silk and gold-wrapped thread*
*Qing dynasty, late Qianlong period (1775–1795)*
*L: 141 cm; W. across shoulders: 183.5 cm.*

Provenance: Spinks, London, January 2, 1991
Unpublished

The Shunzhi emperor (r.1644–1661), the first Qing emperor, rejected the suggestion that his robes be distinguished by the Twelve Ancient Symbols of Imperial Authority, which had adorned the ceremonial and ritual dress of Chinese emperors since the Zhou dynasty (1050–221 BCE). This decision may actually have been a reaction to the suggestion that "Chinese style" robes with "Chinese ornament" be adopted, which would have undermined issues of Manchu identity that had been developed so carefully in the preceding generation. Nonetheless the symbols, particularly the sun and moon on the shoulders, begin to appear on the Qianlong emperor's robes in the 1730s. By 1759, the *Huangchao liqi tushi* edicts added all twelve symbols to the emperor's robes. Their lack of prominence and segregation into three zones reflects Manchu notions of what control of the cosmos meant to the Qing dynasty. Most twelve symbol robes were made for the emperor, although there are many exceptions. From the late eighteenth century onwards, empress's robes often have these symbols; lesser numbers commonly ornament the robes of the heir apparent and his consort.

From the 1630s, *minghuang*, or "bright yellow," was reserved for the robes of the emperor and empress alone. Most of the surviving emperor's coats, including several in this collection, are made of bright yellow fabrics, but the emperor also wore robes of other colours when required by ritual or precedent. This brown colour called *jinhuang*, or "golden yellow," was assigned to the emperor's sons. As such it would have conveyed respect when the emperor called upon his mother, the dowager empress at her residence in the Forbidden City—an event that occurred nearly every morning. There is an informal portrait of the Qianlong emperor, in the style of Castiglione in the Danish National Museum (acc. no. 75.024), shown wearing a brown ground dragon robe, but without the twelve symbols. There is fur-lined brown *kesi*, or tapestry-woven, robe in the Palace Museum, Beijing, Collection which closely resembles 2005.5.625 (see: Palace Museum, Beijing, 2005, pl. 35).

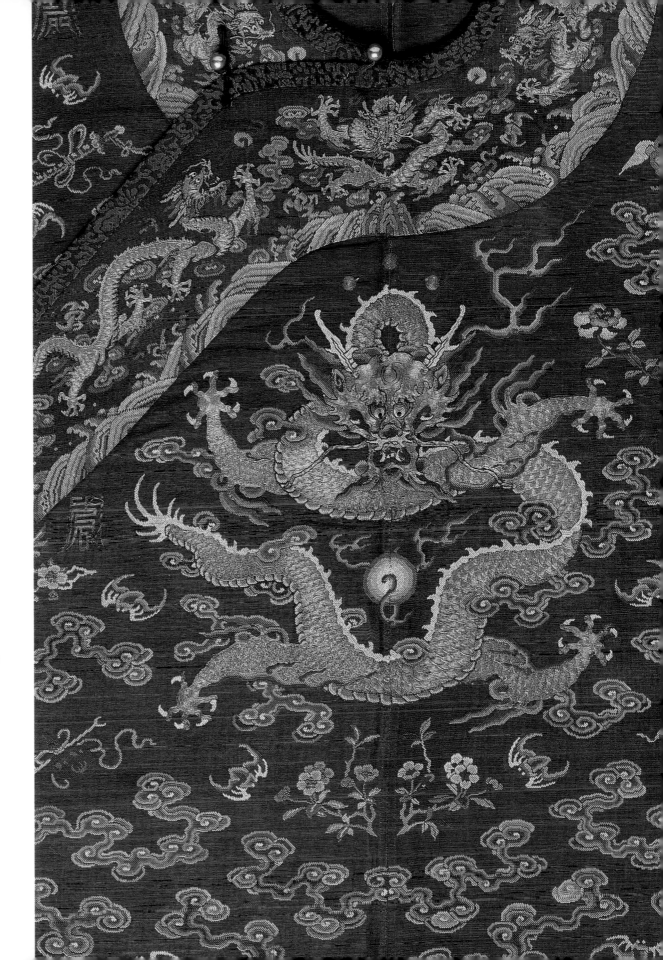

against external threat. The other four outlying fields, occupying the intermediate points of the compass, created a second ring of defense. In traditional Chinese numerology, nine–the sum of three threes–suggests infinity and symbolizes heaven.

The symbolism of the dragon robe as a schematic diagram of the universe was complete only when the coat was worn. The human body became the world's axis: the neck opening, the gate of heaven or apex of the universe, separated the material world of the coat from the realm of the spiritual represented by the wearer's head. This decorative formula was enshrined in the *Huangchao liqi tushi*.

### Twelve Symbols of Imperial Authority

THE QIANLONG EDICTS exalted the emperor's formal and semiformal coats above all others with the addition of the Twelve Symbols of Ancient Imperial Authority. These had been superimposed on basic decorative schema of his robes as they had evolved during the eighteenth century. The Twelve Symbols can be traced to Han dynasty precedent and are related to the sacral roles and ritual obligations of the emperor. These symbols had been used on the official clothing of each succeeding dynasty. They were boldly displayed on the coats of the Ming emperors, but were conspicuously absent from the official dress of the Manchu emperors until 1759. Scholars have speculated that such blatant Chinese symbols were alien to Manchu ideals. They cite the resounding rejection by the Shunzhi emperor to the suggestion by a Chinese official that the new emperor assume the traditional Chinese ceremonial hat and robes with the Twelve Symbols when officiating at the great annual sacrifices.

By reclaiming the imperial use of the ancient Chinese symbols, the Qianlong emperor asserted the mandate of the Manchu imperial clan and the Qing intention of embracing the traditional role of rulers of the Chinese empire as expressed in the *Shujung*, or the Book of History, which was compiled from the last centuries of the Zhou dynasty, probably sixth century BCE to the fourth century CE. It quotes the legendary founding emperor of the pre-Shang dynasty (c. 1600–1027 BCE), Shun, as saying:

> *[My] ministers constitute my legs and arms, my ears and eyes. I wish to help and support my people; you give effect to my wishes. I wish to spread the influence [of my government] through the four quarters; you are my agents. I wish to see the emblematic figures of the ancients–the sun, the moon, the stars, the mountain, the dragon, and the flowery fowl, which are depicted [on the upper garment]; the temple-cup, the aquatic grass, the flames, the grains of rice, the hatchet, and the symbols of distinction, which are embroidered [on the lower garment: I wish to see] all these displayed with the five colours, so as to form the [official robes]; it is your [duty] to adjust them clearly.*[28]

On the Qing robes, the symbols were placed on a coat's shoulders, chest, and back, at waist level and just above the wave border. While some scholars interpret these stylistic and technical features as the debasement of Manchu ideals, this reading ignores the long and complex interaction between the nomadic conqueror and the Chinese empire. The sinicization of the Manchu had actually begun during the fifteenth century when these tribal warriors became tributaries of Ming dynasty emperors. Their longevity as rulers of China was due in large part to their policies of accommodation to and adaptation of Chinese principles.

*Page 49:* Although the Twelve Symbols of Imperial Authority were used to decorate ritual attire of Chinese emperors as far back as the second century BCE, they were conspicuously absent from Manchu emperor's attire until the mid-eighteenth century costume reforms. These emblems, relating to the sacral roles and ritual obligations of the emperor, were arranged in three groups, located at the neck, waist and knee level. The diagram of a semi-formal robe illustrates details (clockwise, top left): flames, pair of dragons, sun, constellation, axe head, temple cups, aquatic grass, *fu* characters, moon, rock, flowery creature, plate of millet.

*Drawing by Richard Sheppard*

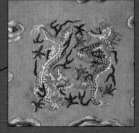
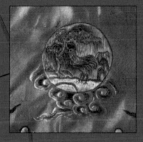

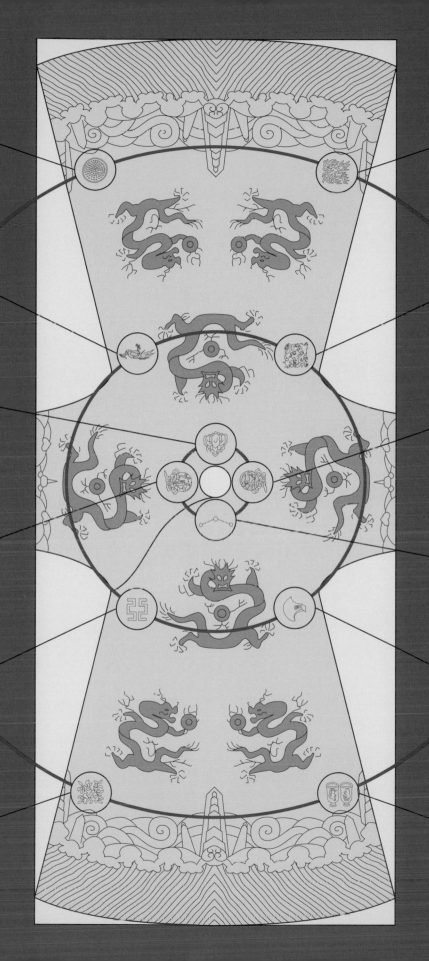

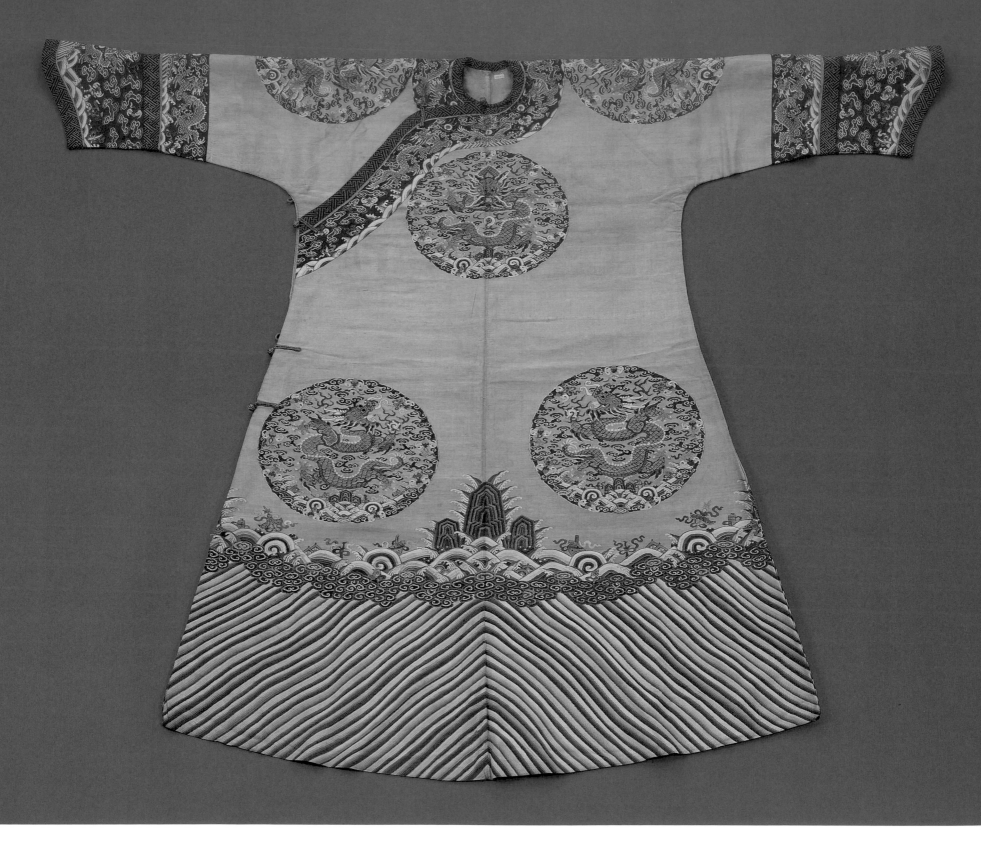

2005.5.11

Jifu, or semi-formal court robe, second style for empress.
*Kesi, or silk tapestry with gold-wrapped threads*
*Qing dynasty Guangxu period (1875–1908)*
L: 145.4 cm; W. across shoulders: 174 cm

Provenance: Acquired at Sotheby's, New York, sale 5158, lot 54, March 16, 1984
Unpublished

Silk tapestry weaving known in Chinese as *kesi*, literally "carved
silk weaving," is a patterned technique in which different
coloured wefts are woven on a single warp only in the areas
required by the design. The technique originated with wool
weaving in the Middle East and was adapted to silk weaving in
Central Asia in the tenth century and was introduced to China
during the twelfth and thirteenth centuries. The time-consuming
technique was expensive and coveted for prestigious garments
like this empress's *jifu*. During the eighteenth century it became
increasingly popular to enhance fine details with paint.

A virtual duplicate of this robe, utilizing the same cartoon,
is in the Minneapolis Institute of Arts Collection (acc. no. 24.89;
see: Robert Jacobsen, 2002, vol. 1, pp. 64–65).

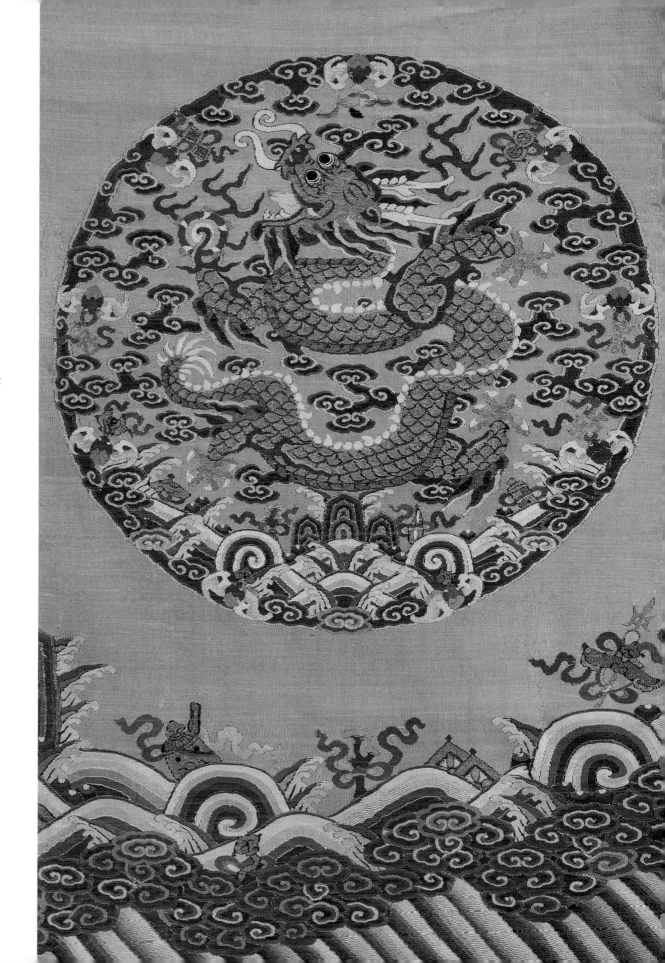

2005.5.312

*Longgua*, or consort's semi-formal court
surcoat, second type.
*Silk twill embroidered with floss silk and*
  *gold-wrapped threads*
*Qing dynasty, Guangxu period (1875–1908)*
*L: 138 cm; W. across shoulders: 146.6 cm*

*Provenance: Acquired from Sotheby's New York, sale 4688*
  *lot 267, September 19, 1981*
Unpublished

For most official occasions, imperial
women wore surcoats decorated with
dragon roundels to indicate rank. Unlike
male equivalent garments, which were
knee-length, female *longqua* were worn
full length, completely covering the
patterned robe worn beneath it. The
dragons in the lower roundels with curly
bodies and two toes were called *qui*,
water dragons. They were reserved for
lower-ranking imperial consorts.

## Producing the Imperial Wardrobe

INITIALLY, the Qing imperial court regulated
formal attire made of dragon-patterned silks, rigor-
ously monitoring proscribed colours and patterns.
By the end of the seventeenth century, as the silk-pro-
ducing regions of central China came under Qing
government control, officials were given greater
access to the factories and workshops that produced
goods for the court. Qing imperial practice of man-
aging the officially-appointed court silk factories,
called *jizaoju,* of which there were three–Suzhou,
Hangzhou and Nanjing–plus a Beijin *jiranju*, or silk
workshop, was to allow the private sale of excess
production. While this management system, which
had been established in the fourteenth century by
the Yuan dynasty and continued under the Ming
dynasty, helped stimulate the silk industry as a
whole, it also sowed the seed of abuse of garment
types and imagery that distinguished entitlement
and privilege.

The imperial silk factories were renowned for the
excellence of their production and for the most per-
fect goods suitable for the Son of Heaven. During the
Qing dynasty, orders for robes and textile furnishings
for the use of the emperor and his family–essen-
tially the imperial clan–was organized through
the *Neiwufu*, or Office of the Imperial Household.
Established in 1661 to manage details involved with
the emperor's food, clothing, and shelter, the *Neiwufu*
eventually included a staff of over 1,600. It managed
56 offices, special schools and workshops to oversee
the maintenance of the imperial palaces, and gardens.

Each clothing or accessory item that formed the
official wardrobe of the emperor and his family was
individually designed. Renderings of garments and
their decoration were prepared for inspection, and,
once approved, forwarded to the imperial silk facto-
ries to be manufactured to specifications. Since nearly

every garment required several different fabrics, their
production had to be co-ordinated by the factories.
All components for a single garment were packaged
in yellow paper and sent to the capital, where they
were inspected by the appropriate official of the
*Neiwufu* and placed in storage until required for tai-
loring. Each year, thousands of cloth pieces were
produced to ensure the imperial household was sup-
plied with appropriate clothes and palace
furnishings, which were required for many daily
public and private functions.

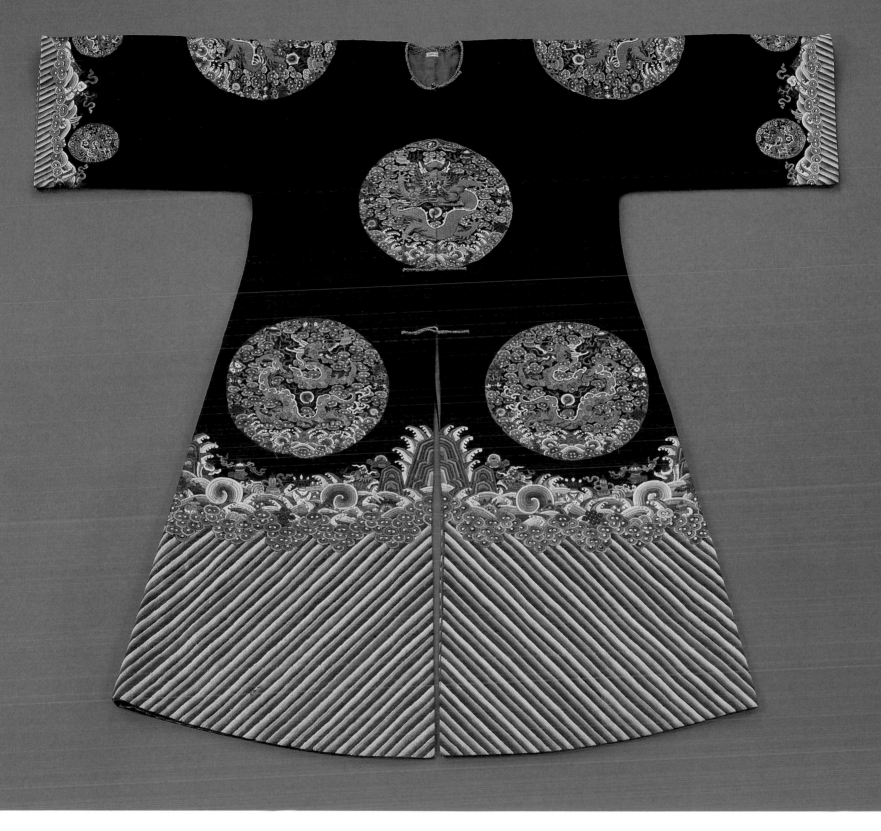

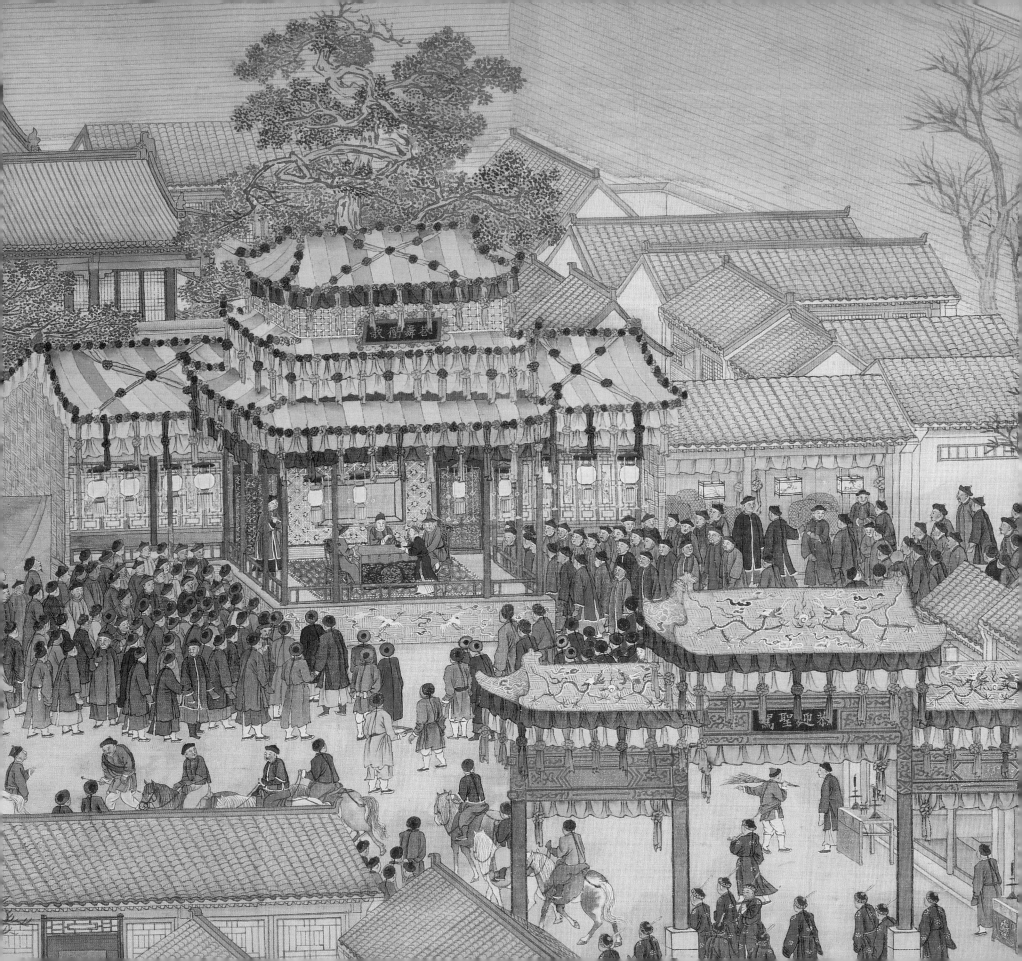

# Dragon Robes in Chinese Society

CHINESE SOCIETY was emphatically secular, drawing its definition and direction from imperial law and historical precedent. Those appointed to administer and enforce the decrees emanating from the emperor attained social recognition and they enjoyed the privileges of rank. From the earliest periods of Chinese civilization, court rank was the key determinant of social status, economic stability, and prestige. So pervasive was the belief in the authority of a central government that the court also served as a model for both domestic and religious life. At family gatherings like weddings, birthdays, or New Year celebrations, the patriarch and his wife sat on throne-like chairs to receive homage of family members ranked, like courtiers, by generation, birth order, and gender. Similarly, pantheons of gods and goddesses were thought to hold court when they received the adoration of the faithful.

These attitudes about politics and society, and even religion, were shaped by teachings of the fifth century BCE philosopher Confucius. Confucius wrote and compiled a set of works collectively known as the Five Confucian Classics, which describe and celebrate an idealized period of social stability and peace

under the Western Zhou kings (c.1050–771 BCE), considered China's golden age. According to Confucius, the reason for the unrest that characterized his time was that people no longer understood their assigned roles and place in society, which required them to defer to superiors, but acknowledge the needs of inferiors. He proposed a code of conduct based on the family with its precisely defined relationships with the family patriarch at the apex of authority. By extension, Confucius argued that the family was the basis for an ordered political life. Like a family, every member of the imperial court looked to the emperor as father of "all under Heaven." The authority of the head of a family was assumed and the right of rulers to rule was unquestioned. Nevertheless, the ruler, like a father, was morally obliged to rule for the benefit of society.

Although court dress was rigorously regulated, court-style clothing, particularly dragon-decorated coats, proliferated throughout Qing society. These quasi-official garments often shared the design strategies for court attire illustrated in the *Huangchao liqi tushi*, but existed outside the proscriptions governing those garments. For nearly twenty-five hundred

The emperor's route has been marked with ceremonial gates and temporary pavilions, like this one on which actors perform to entertain the crowds that eagerly await the emperor's arrival in Dezhou.

Xu Yang (active c.1750–1776) and assistants, detail from the second scroll of *Nanxuntu diqi juan* (Pictures of the Southern Tour). Dated to 1770. Hand scroll: ink and colour on silk; 68.8 cm. x 1686.5 cm. University of Alberta Museums, Mactaggart Art Collection 2004.19.15.1. © 2007 University of Alberta

2005.5.106

*Longpao*, or dragon robe for an actor.
*Silk satin brocaded with floss silk, gold-*
*wrapped threads and strips of gold paper*
*Qing dynasty, early-eighteenth century style,*
*probably second half of the nineteenth*
*century*
L: 124.3 cm; W. across shoulders: 222 cm

*Provenance: Acquired from Stephen McGuinness, Hong*
*Kong, 1986*
*Published: Vollmer, Ruling from the Dragon Throne,*
*2002, fig. 2.8, p. 32.*

Theatrical performances offered the masses a vision of the imperial court. Only a very few attended court and far fewer were ever permitted to be in the presence of the emperor. Actors playing the roles of mythic emperors and famed courtiers, as well as gods, required court-like robes with dragon patterns. This robe, made for an opera company, possibly under imperial patronage of the Qing court, is patterned after earlier designs and retains the voluminous sleeves evoking the court attire of the previous Ming dynasty (1368–1644). The lining bears two sets of theatre company marks stamped in ink—one set has been struck out.

years, marriage customs and wedding rituals have involved elaborate preparations to mark the transition of a bride from her birth home to the home of her husband. On a domestic level, marriage celebrated her roles as consort and future mother of sons—a reflection of the roles played by the empress on behalf of the state. The transfer of her dowry and trousseau, as well as the procession of that accompanied her to her new home, emulated imperial practice. The bride, like an empress, rode in a sedan chair accompanied by musicians and attendants carrying lanterns and banners. She was dressed in red, the ancient colour of celebration and happiness. Her hair was especially arranged and her face veiled. Throughout the Qing dynasty, Han-Chinese brides wore robes styled on the court attire of the previous Ming dynasty: a three-quarter-length robe with wide sleeves was worn over skirt-like paired aprons. Over it was worn a vest, called *xiapei*, often bearing rank badges. This garment had evolved from a Ming dynasty court stole that indicated rank. In emulation of the empress, a Han-Chinese bride's coat was typically decorated with dragons. By the nineteenth century, Manchu brides copied Han-Chinese custom, but the styling of the garments continued to reflect Manchu national characteristics

Bride grooms, whose role by extension reflected that of the emperor, might wear dragon robes for their weddings. Little boys also wore miniature dragon robes at important family celebrations like New Year and special birthdays. Like the bride groom's robes, these were posturing clothes. For boys, they reflected future aspirations as grooms to produce the next generation of the family, but also reflected the goal of Confucian education, which was to pass a series of civil service examinations that qualified the male for an imperial court appointment.

In contrast to the private use of dragon-patterned robes within families, Qing society also had opportunities to see dragon robes in public. While none would have viewed the emperor or his family and few people would have had occasion to see a representative of the imperial government in action at the *yamen*, or local government office, many people would have enjoyed opera performers and actors portraying legendary princes and princesses wearing dragon-patterned robes. It was customary to have new clothes for the New Year. Statues of gods in local Buddhist and Daoist temples were often dressed in new dragon robes on this occasion.

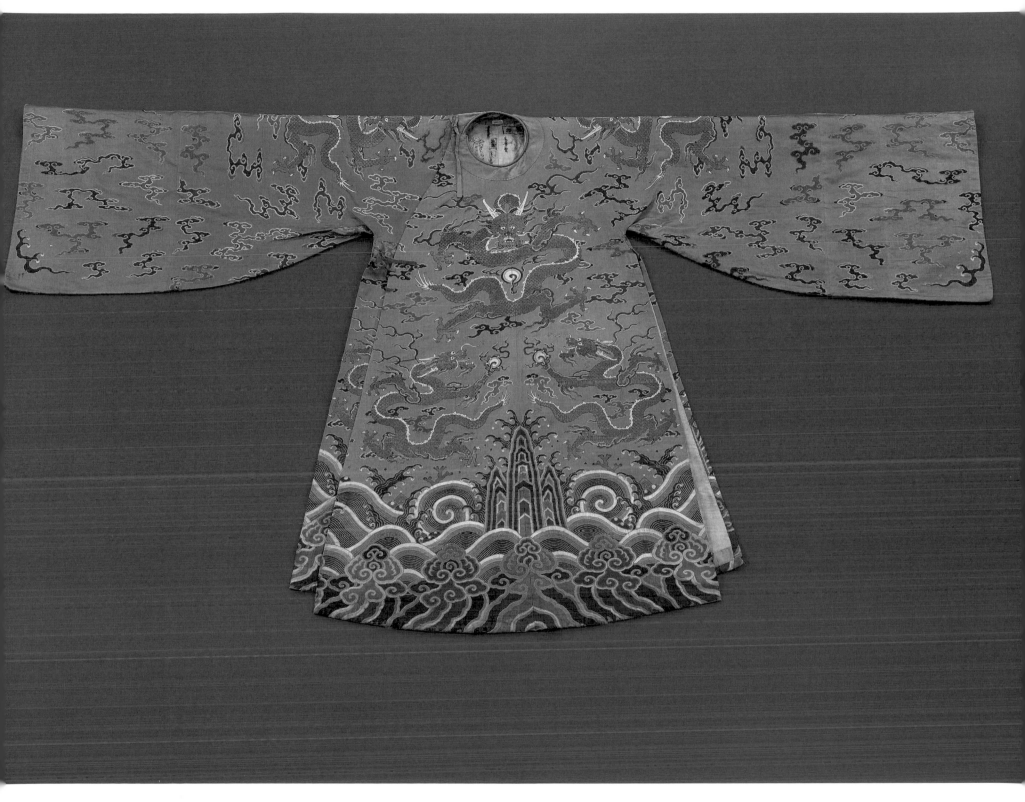

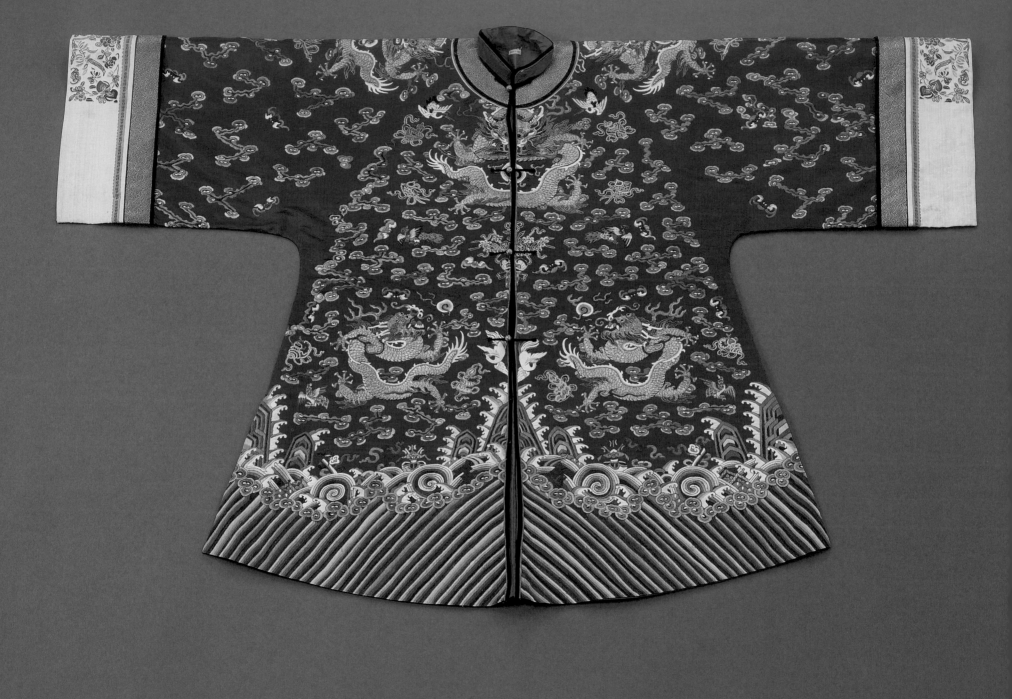

2005.5.195

Han-Chinese bridal coat, or *mangao.*
*Silk satin embroidered with floss silk and gold-wrapped thread*
*Qing dynasty, nineteenth century, third quarter*
*L: 106.5 cm; W. across shoulders: 156 cm*

*Provenance: Acquired from Mary Shen, London 1985*
*Unpublished*

On the occasion of her wedding, a bride was regarded as
an "empress for the day," and her clothing and accessories
were marked with imperial symbols. A bride represented
the possibility of children   the most valuable asset of the
Confucian family. Through marriage came status and security;
ultimately a woman could attain control of the household as
the mother of a son.

*Right:* Bridal attire was the most prestigious dress most women
wore, hence Han women were often depicted wearing these
garments in the posthumous portraits created for family rites
honouring their ancestors.

*Anonymous, unidentified Han-Chinese woman's portrait; late-nineteenth century.*
*Hanging scroll: ink and colour on paper; 114.8 cm x 75.7 cm. University of Alberta Museums,*
*Mactaggart Art Collection 2004.19.78.1. © 2007 University of Alberta*

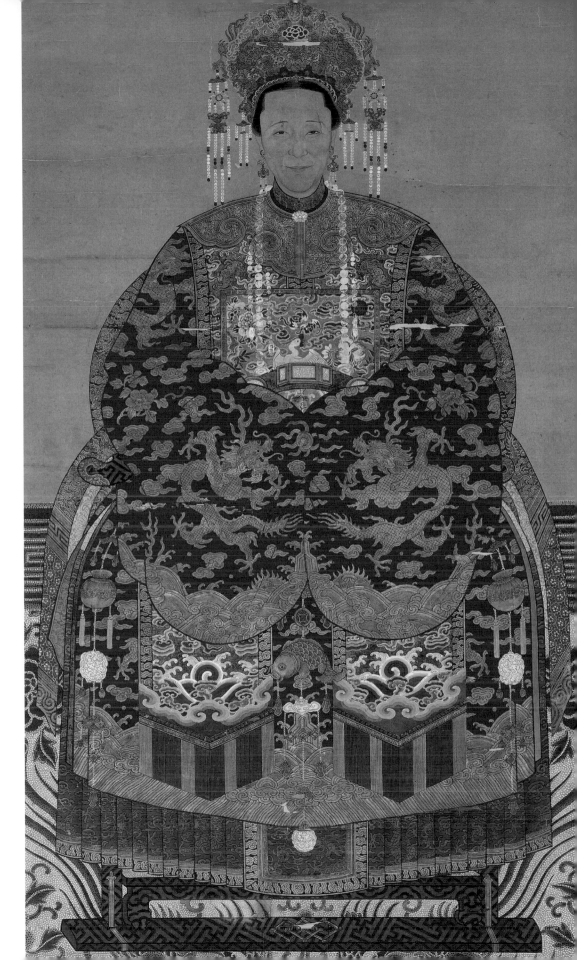

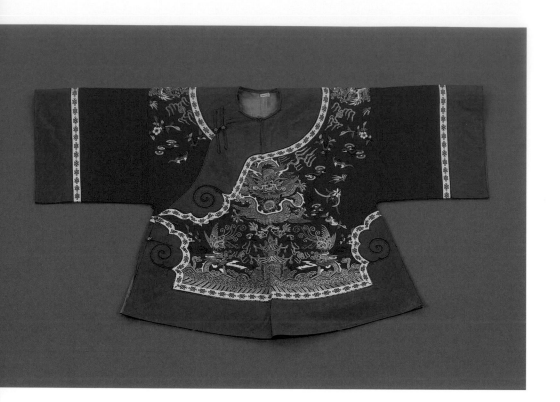

2005.5.168

Han-Chinese bridal-style coat for child, or *mangao*.
*Silk satin, embroidered with floss silk and gold-wrapped thread*
*Qing Dynasty, 1875–1900*
*L: 68.5 cm; W. across shoulders: 109.6 cm.*

*Provenance: Acquired at Liberty's, London, 1985*
*Unpublished*

The goal of every girl was to become a bride. Many ceremonial
clothes for female children were patterned after the robes they
aspired to wear as adults, similar to the miniature dragon robes
their brothers often wore on New Years and for family birthdays.

2005.5.198

Manchu bridal coat, or *longpao*.
*Silk satin embroidered with floss silk and gold-wrapped threads*
*Qing Dynasty, 1875–1900*
*L: 142.1 cm; W. across shoulders: 212.5 cm*

*Provenance: Acquired from Sotheby's New York, sale H883Y lot 127, June 2, 1983*
*Unpublished*

Manchu women wore garments styled to reflect their superior
status within the society of the empire. Nonetheless, their
garments, and particularly the decoration used to ornament
them, were influenced by Han-Chinese practices. By the
eighteenth century, Manchu brides, like their Han-Chinese
counterparts, were dressing in court-inspired clothes. This
dragon robe is virtually identical to a court *jifu*, or semi-formal
court robe, except for the red background. Red had both political
and aesthetic meanings. It had been the official colour of the
preceding Ming dynasty. But more basically, one of the concepts
of ancient Daoist philosophy was the notion that all of nature
was made up of varying combinations of five components:
wood, metal, fire, water, and earth. Known as *wuxing*, or Five
Phases, the concept explained all phenomena, including the
seasons and times of life. Colours represented these five phases.
Red symbolized the element fire, which expressed wishes for
happiness and connoted the summer or prime of life. Red
clothing was traditionally used for celebrating major events
within the family—birth of children, weddings, and significant
birthdays.

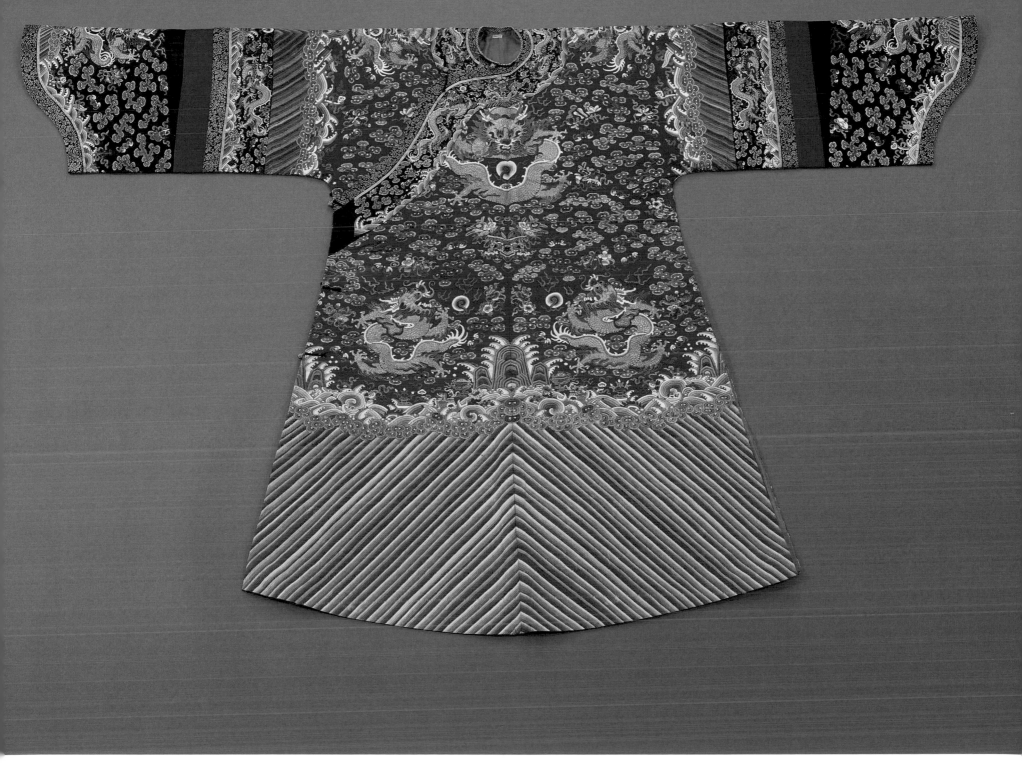

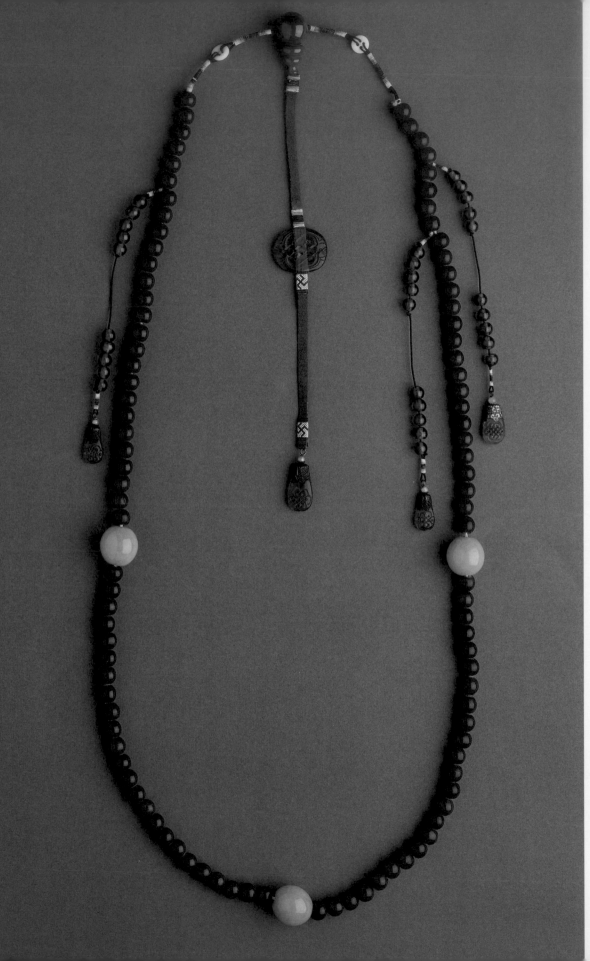

2005.5.352

*Chaozhu*, or court necklace.
*Glass imitating coral and jadite and jade, silk cords and tapes*
*Circumference: 133 cm*
*Qing dynasty, late nineteenth century*

Provenance: Acquired from Sotheby's New York, sale H883Y lot 127, June 2, 1983
Unpublished

Court necklaces were based on Buddhist rosaries with 108 beads divided into four sets of twenty-seven by larger spacers called *futou*, or Buddha beads. The long pendant hanging down the back acted as a counterweight to keep the necklace in place. Three small pendants attached to the necklace were called *shuzhu*, or counting strings; each had eight *jinianer*, or memory beads. Women wore the *chaozhu* with the single counting string on the left and the pair of the left. *Chaozhu* were restricted to imperial nobility and officials to the fifth rank. Only high-ranking women wore triple necklaces as illustrated in the *Huangchao liqi tushi album* (see page 21). Although the materials for each rank was prescribed, including the stones and colour of the silk tapes and cords, in practice many court necklaces were made of glass, imitating jade, amber and coral.

# Conclusion

THE LASTING SUCCESS of the Manchu imperial enterprise rested on series of deliberate and decisive actions that first remade the Manchu people into a unified, disciplined military society that could focus its energies on conquest, initially in North Asia, later of the vast Ming dynasty empire.

Second, the Aisin Goro clan, the principle clan group, consciously crafted a multilingual and multinational state to counteract the threat of assimilation by overwhelming numbers of Han-Chinese that defeated all alien conquerors in the past. Initially they recruited Mongol tribesmen, Koreans and Han-Chinese settlers from their own homeland on the Liaoning peninsula and adjacent regions north of the Great Wall. Eventually Inner Asian Mongols, Turkestan Muslims, Tibetans, North Asian tribal groups, as well as Han-Chinese and its minorities, were brought under the control of the Qing imperial government. By the eighteenth century, Qing emperors ruled over the largest land mass ever controlled by a Chinese imperial government.

Third, the Manchu established a Chinese-style imperial bureaucracy to administer the details of the Qing government for the prior to the conquest, thus facilitating the transition to control of the two thousand year-old Confucian Chinese state.

Hongtaiji was the first Manchu leader to claim to the Chinese title *huangdi,* or emperor. His successors, as the Son of Heaven, inherited the heaven-blessed mandate to moral rule, but they were the first to exercise control as truly universal rulers. Although successful for nearly three hundred years, the Qing government was unable to stave off the economic and political decline that made it vulnerable to the aggressive actions of European, American and Japanese national interests. Although the old Chinese imperial system passed into history in 1911, the legacy of Manchu notions of nationality and ethnicity continue to affect the actions and reactions of China in the twenty-first century.

Throughout their history, the Manchu were keenly aware that the images they projected were especially important and powerful. From the outset, dress was an essential tool to underscore legitimacy and heritage. In the early sixteenth century, the Manchu literally wrote themselves into existence by

A shop owner displays lined winter garments which their owners have probably pawned for the season.

creating origin myths, divine ancestors and a unique form of dress. Horsehoof cuffs, a curved front overlap on their coats and loop-and-toggle fastenings defined Manchu identity, and eventually affected the dress of all populations in the widespread empire. The redesign of the imperial wardrobe during the eighteenth century, which is the subject of this volume, brought the cosmic purpose of imperial rule into sharp focus. The force of court coat iconography, with its carefully arranged pattern of dragons amid clouds above the universal ocean washing against the earth mountain, quickly transcended the political and

ethnic priorities of imperial government to become universal symbols of the empire. Today Qing-style dragon robes remain emblems representing "China." The Mactaggart Art Collection at the University of Alberta is a remarkable resource. Its scope and diversity encourages the examination of political, cultural and social developments in East Asia; but it also affords opportunities for exploring technical and aesthetic developments through which we gaining insights and appreciation for the rich and complex history of China.

## Works in the Exhibition

2004.19.1.1.1–.68
Anonymous, *Huangchao liqi tushi* (Illustrated
  Precedents of the [Qing] Imperial Court):
  *see pages 3, 18, 19 and 20*

2005.5.7
*Jifu*, or semi-formal court robe, first style for an
  imperial consort: *see pages 14, 15 and 16*

2005.5.9
*Jifu*, or semi-formal court robe, third style for
  empress *see pages v, and 24*

2005.5.11
*Jifu*, or semi-formal court robe, second style for
  empress: *see pages 40 and 41*

2005.5.79
*Jifu*, or semi-formal court robe for imperial prince:
  *see pages 10 and 11*

2005.5.106
*Longpao*, or dragon robe for an actor: *see page 47*

2005.5.107
*Chuba*, or robe for aristocratic man made from
  empress *longgua*, or court surcoat for an empress:
  *see page 26*

2005.5.168
Han-Chinese bridal-style coat for child, or *mangao*:
  *see page 50*

2005.5.195
Han-Chinese bridal coat, or *mangao*: *see page 48*

2005.5.198
Manchu bridal coat, or *longpao*: *see page 51*

2005.5.238.1
Roundels cut from an imperial *longpao*, or dragon
  coat: *see page 32*

2005.5.312
*Longgua*, or consort's semi-formal court surcoat,
  second type: *see pages 42 and 43*

2005.5.352
*Chaozhu*, or court necklace: *see page 52*

2005.5.367
*Changfu*, or informal court robe for empress:
  *see page 25*

2005.5.625
12-symbol *jifu*, or semi-formal court robe for
  emperor: *see pages 36 and 37*

## Further Reading

Cammann, Schuyler V. R. *China's Dragon Robes*. New York: The Ronald Press, 1952. Reprint, Chicago: Art Media Resources, Ltd., 2001.

Chi Jo-hsin and Chen Hsia-sheng. *Qingdai fushi zhanlan tulu* (Ch'ing Dynasty costume accessories). Taipei: National Palace Museum, 1986.

Crossley, Pamela Kyle. *A Translucent Mirror: History and Identity in Qing Imperial Ideology*. Berkeley: University of California Press, 1999.

——. *The Manchus*. Oxford: Blackwell Publishers, 1997; revised 2001.

Dickinson, Gary, and Linda Wrigglesworth. *Imperial Wardrobe*. Berkeley: Ten Speed Press, 2000.

Huang Nengfu and Chen Juanjuan. *Zhongguo fushi yishu yuanliu* (Origins of the art of Chinese national costume). Beijing: Zhongguo luyou chubanshe, 1994.

Jacobsen, Robert D. *Imperial Silks: Ch'ing Dynasty Textiles in the Minneapolis Institute of Arts*. 2 vols. Minneapolis: Minneapolis Institute of Arts, 2000.

Kuhn, Dieter. *Le Vêtement sous la Dynastie des Qing: La Cité interdite, vie publique et privée des empereurs de Chine 1644–1911*. Paris: Association Française d'Action Artistique Ministère des Affaires étrangères, 1997.

Lee, Robert H. G. *The Manchurian Frontier in Ch'ing History*, Cambridge, Mass.: Harvard University Press, 1970.

Medley, Margaret. *The Illustrated Regulations for Ceremonial Paraphernalia of the Ch'ing Dynasty*. London: Han-Shan Tang, 1982.

Palace Museum, Beijing. *Gugong bowuyuan cang wenwu zhenpin quanji 51: Qingdai gongting fushi* (The Complete Collection of Treasures of the Palace Museum 51: Costume and Accessories of Emperors and Empresses of the Qing Dynasty). Hong Kong: The Commercial Press (Hong Kong) Ltd., 2005.

Priest, Alan. *Costumes from the Forbidden City*. New York: Metropolitan Museum of Art, 1945.

Rawski, Evelyn S., *The Last Emperors: A Social History of Qing Imperial Institutions*, Berkeley: University of California Press, 1998.

Rawski, Evelyn S. and Rawson, Jessica, eds. *China: The Three Emperors 1662–1795*. London: Royal Academy of Arts, 2005.

Rossabi, Morris. *China and Inner Asia*. New York: Pica Press, 1975.

Roth Li, Gertraude. "Rise of the Manchus," in Peterson, Willard J. ed. *Cambridge History of China*, vol. 9. part 1, pp. 9–51. Cambridge: University Press, 2002.

Stuart, Jan, and Evelyn I. Rawski. *Worshiping the Ancestors: Chinese Commemorative Portraits*. Washington D.C. and Stanford: Stanford University Press, 2001.

Ter Molen, J. R., and Ellen Uitzinger, eds. *De Verboden Stad/The Forbidden City*. Rotterdam: Museum Boymans-van Beuningen, 1990.

Vollmer, John E. *Chinese Costume and Accessories 17th–20th century*. Paris: Association pour l'Étude et la Documentation des Textiles de Asie, 1999.

——. *Ruling from the Dragon Throne: Costume of the Qing Dynasty (1644–1911)*. Berkeley: Ten Speed Press, 2002.

Wakeman, Frederic, Jr. *The Great Enterprise: The Manchu Reconstruction of Imperial Order in Seventeenth-Century China*. 2 vols. Berkeley, Calif.: University of California Press, 1985.

Zhao Xiuzhen, et.al. *Beijing wenwu jingcui daxi: zhixiu juan* (Series of the Gems of Beijing Cultural Relics: Textiles and Embroidery), Beijing: Publishing House, 1999.

## Notes

1   Shakespeare, William. *As You Like It*, Act II, Scene vii, Lines 139–142.

2   Vollmer, John E. *Ruling from the Dragon Throne: Costume of the Qing Dynasty (1644–1911)*. Berkeley, CA: Ten Speed Press, 2002.

3   Crossley, Pamela Kyle. *A Translucent Mirror: History and Identity in Qing Imperial Ideology.* Berkeley: University of California Press, 1999, pp.207–208; Elliott, Mark C. *The Manchu Way: The Eight Banners and Ethnic Identity in Late Imperial China.* Stanford, Calif.: Stanford University Press, 2001, pp. 56–63; Roth Li, Gertraude. "Rise of the Manchus," in Peterson, Willard J. ed. *Cambridge History of China*, vol. 9. part 1. Cambridge: University Press, 2002, pp. 24–27.

4   Medley, Margaret. *The Illustrated Regulations for Ceremonial Paraphernalia of the Ch'ing Dynasty.* London: Han-Shan Tang, 1982; Dickinson, Gary and Linda Wrigglesworth. *Imperial Wardrobe.* Berkeley, Calif.: Ten Speed Press, 2002, pp. 20–30.

5   Elliott, op. cit., pp. 42–56.

6   Tillman Hoyt Cleveland and Stephen H. West (eds). *China under Jurchen Rule: Essays on Chin Intellectual and Cultural History.* Albany: State University of New York Press, 1995, pp. 23–38.

7   Roth Li, op. cit., pp. 9–51.

8   Roth Li, op. cit., p. 23.

9   Wakeman, Frederic. *The Fall of Imperial China.* New York: The Free Press, 1975, pp. 71–84.

10  Elliot, op. cit., pp. 71–79.

11  Vollmer, op. cit., pp. 35–41.

12  Hansen, Henny Harold. *Mongol Costume.* Reprint, New York: Thames and Hudson, 1994; Sodnom, B. (ed.). *National Costumes of the Mongolian People's Republic,* Ulan Baator: State Publishing House, 1967.

13  Cammann, Schuyler V. R. *China's Dragon Robes.* New York: The Ronald Press, 1952. Reprint, Chicago: Art Media Resources, Ltd., 2001, p.21, pp. 26–29.

14  Dickinson and Wrigglesworth, op. cit., pp. 116–118.

15  Vollmer, op. cit., pp. 59–79.

16  Cammann, op. cit., p. 21.

17  Ibid, pp. 23–26.

18  Ibid, pp. 26–49.

19  Dickinson and Wrigglesworth, op. cit., pp. 144–197; Vollmer, op. cit., pp. 81–85.

20  Stuart, Jan and Evelyn I. Rawski. *Worshipping the Ancestors: Chinese Commemorative Portraits.* Washington D.C. and Stanford, 2001, pp. 124 and 137.

21  Vollmer, op. cit., pp. 114–116.

22  Adapted from Stuart and Rawski, op.cit. p. 124, p. 132; Schuyler V. R. Cammann. "Development of the Mandarin Square." *Harvard Journal of Asian Studies* 8 (1944), pp. 71–130; Dickinson and Wrigglesworth, op. cit., pp.170–198.

23  Uitzinger, Ellen, "Emperorship in China," in Ter Molen, J. R. and Ellen Uitzinger (eds.), *De Verboden Stad/The Forbidden City*. Rotterdam: Museum Boymans-van Beuningen, 1990, pp, 71–91; Vollmer, John. E. "Power in the Inner Court of the Qing Dynasty: The Emperor's Clothes," in Ho, Chuimei and Cheri A. Jones (eds.), *Proceedings of the Denver Museum of Natural History*, vol. 3, no. 13 (summer 1998), pp. 49–54.

24  Dickinson, Gary and Wrigglesworth, Linda. *Imperial Wardrobe*. Berkeley, Calif.: Ten Speed Press, 2002, pp. 21–22.

25  Cammann, op. cit., p. 50.

26  Zhao, Feng. *Treasures in Silk*. Hong Kong: The Costume Squad, 1999, pp. 264–271.

27  Watt, James C. Y. and Anne E. Wardwell. *When Silk was Gold: Central Asian and Chinese Textiles*. New York: The Metropolitan Museum of Art, 1997, pp. 116–117.

28  *Shujing*, pt. II, bk. IV, ch. I.4, p. 281 in Legge, James (trans.) Shujing (Book of History), *The Chinese Classics*, III, IV. London: Oxford University Press, 1865. Reprint, Hong Kong: Hong Kong University Press, 1960.